THE
INTERNET
& ART

A GUIDEBOOK FOR ARTISTS

BARBARA HOUGHTON

D1501956

Upper Saddle River, NJ 07458

Library of Congress Cataloging-in-Publication Data

Houghton, Barbara, (date)
 The Internet and art : a guide book for artists / Barbara Houghton.
 p. cm.
 Includes index.
 ISBN 0–13–089374–9
 1. Computer graphics—Study and teaching. 2. Computer-aided design—Study and
teaching. 3. Web sites—Design. 4. Art—Computer network resources. I. Title.

NC1000 .H678 2001
006.6′776—dc21

00–069288

AVP, Publisher: Bud Therien
Editorial Assistant: Wendy Yurash
Managing Editor: Jan Stephan
Production Liaison: Fran Russello
Project Manager: Karen Berry/Pine Tree Composition
Prepress and Manufacturing Buyer: Sherry Lewis
Art Director: Jayne Conte
Cover Designer: Kiwi Design
Marketing Manager: Sheryl Adams

This book was set in 10/12 Minion by Pine Tree Composition, Inc.,
and was printed and bound by Hamilton Printing.
The cover was printed by Phoenix Color Corp.

 © 2002 by Pearson Education, Inc.
Upper Saddle River, New Jersey 07458

Printed in the United States of America
10 9 8 7 6 5 4 3 2 1

ISBN: 0-13-089374-9

Prentice-Hall International (UK) Limited, *London*
Prentice-Hall of Australia Pty. Limited, *Sydney*
Prentice-Hall Canada Inc., *Toronto*
Prentice-Hall Hispanoamericana, S.A., *Mexico*
Prentice-Hall of India Private Limited, *New Delhi*
Prentice-Hall of Japan, Inc., *Tokyo*
Pearson Education Asia Pte Ltd., *Singapore*
Editora Prentice-Hall do Brasil, Ltda., *Rio de Janeiro*

CONTENTS

PREFACE

Katie's Cookbook, http://artwork-inform.com/katie/.

THIS BOOK WAS WRITTEN to address a need for a college-level textbook for artists and art students to assist them in creating websites to showcase their creative work. It contains overviews of some available software with tutorials for those I felt were most likely to be used by artists and art students. There are many links to example websites that will be helpful to study while beginning to create sites of your own.

When I began teaching computer graphics courses about fifteen years ago, there were very few students who had any computer skills. We were all learning together. Now, I find that each year more students have an understanding of the technology when they walk into class. Many have used email, Photoshop, browsers for the Internet, word processing, and drawing programs. Many have been downloading their music from websites and creating their own CDs. Even if the students do not own their own computers, they have access to computers in the university labs around campus and at the library.

Since most artists and art students in the United States use the Macintosh, I have written from that perspective. Most of the software programs work seamlessly on the PC platform also. Those who use this book and are on the PC platform should not have any problem with tutorials provided.

I suggest that you supplement this text with the software manuals accompanying your lab's software and that you visit the help pages on the various software company sites to get further clarification on software operation and use.

When I began this project, there were times I questioned the quality of my choices. Writing about the Web is one thing, but trying to write a textbook for students to use that is timely is another. Software and technology are changing at the most rapid of speeds. Assimilating that change is a huge task in itself. So, I apologize here for any slowness on my part with keeping up with the changing world of the Internet and especially the World Wide Web.

A few months into this project, I began to get a funny feeling about my favorite software, a product from Adobe called ImageStyler. I had begun to teach with this software and was noticing in the ads in the trade journals, mail order houses, and at Adobe's own website that this product was unmistakably missing from the new web bundles and all the promotions. I considered it a great product and, in fact, had my students buzzing along making web pages using it with considerable ease. I called my publisher and voiced my concern about writing tutorials about a

product that was on its way out. He urged me to investigate to find out what I could about the software. I tried the Users to Users group at Adobe to find out what was going on and, with the help of Bruce Quackenbush, I eventually wound up speaking with the manager of a new product that Adobe was introducing that was partially built on the platform of ImageStyler. Eric Hess at Adobe in the then Ground Zero team was very helpful to me and understood my plight. When he went on paternity leave, he turned over the reins to Lynly Schambers. Lynly and her LiveMotion teammates were very helpful to me while I was trying to write about a product still not on the market, but in the beta stages. One of the technical staff members, Michael Ninness, filled me in on tutorials and answered questions that my class and I raised while using a beta version we downloaded. We found this new program pretty easy to use with its intuitive interface and similarity to ImageStyler. Students were making web pages with animations within the first half-hour the program was installed. So, for all the help and encouragement I have received from the folks at Adobe, my hat is off to you. You understand how important alliances with education are for your future and that of creative folks everywhere. Other software assistance came from the folks at Macromedia. I thank them for their assistance in this.

From the students in my class at Northern Kentucky University, I received great encouragement for the writing I was doing. They gave me ideas of what needed expansion and more clarity. They also lent me images for this book. Their critical eyes as end users of the book and some of the products it talks about were crucial to my ability to move ahead. The members of that class, Art and the Internet, were: Ray Bridewell, Christi Doerhoefer, Scott French, Jason Gillispie, Kelly Grether, Joe Kiefer, Gary Klatzke, Scott Leifling, Nicci Mechler, Ann Morgan, Jeff Roy, and Keri Yates.

For all the artists, webmasters, and organizations who lent me screen grabs of their work to illustrate the ideas in this book, my greatest thanks. Without all of you, the Web would be a much duller place. These folks have done excellent work and provided a wealth of information for artists to use freely. That great spirit should be rewarded by the satisfaction they get from seeing their job so well done.

Special thanks go to Dr. Donald Kelm and Professor Barry Andersen, who tried to lighten my load while I worked on this manuscript. I also would like to cite Dr. Gail Wells, Dean of Arts and Sciences, and Dr. Rogers Redding, Provost and Academic Vice President of Northern Kentucky University, for their encouragement.

Most of all I would like to thank Keith Farley, my husband, for doing the dishes, cleaning the house, and being my moral support while I wrote this book and slacked on all my household duties. He also has been a great resource for technical information about the Web, websites, and their construction. Keith is also an artist who makes wonderful jewelry, sculpture, and designs for the Web. He runs his own business using the Web as his vehicle for designing custom jewelry for folks all over the world. He has also designed websites for our favorite bed and breakfasts in Florence, Italy and in France, among others.

I would like to dedicate this book to my mom, Katie Hemmingway. When I was young and complaining about being unable to do something that she knew I could do, Katie used to tell me: "Can't never did anything!" She would then send me back to try again. Katie raised twelve of us children with the help of my dad. She taught her children to push harder, not to give up, and to love those around you. Thanks, Mom.

Please use this book knowing full well that software changes with upgrades so not everything you read here may work exactly as I say. Also remember that each of us uses software differently, based on our needs and our familiarity with the programs. There are often many ways to approach the same problem and many solutions to that problem. If you understand that there is never one correct way to do things when making art, using this book, or just living life, we will build a relationship that may extend into the future. Have a good adventure and make wonderful places for us to visit on the Web.

Barbara Houghton
Professor of Art
Northern Kentucky University

1

A BRIEF HISTORY
OF THE
INTERNET
AND THE
WORLD WIDE WEB

Example of a web page made in Adobe's PageMill.

IN THIS CHAPTER, we will follow the developmental history of the Internet and the World Wide Web. We will also see how the Internet works and briefly look at the computer language that is the basis for the WWW.

BRIEF HISTORY

1960s

The Advanced Research Projects Agency (ARPA) was commissioned in the late 1960s and funded by the Defense Advanced Research Project Agency (DARPA) to create a network. The ARPAnet, as it was called, was what has turned into the Internet. By 1969, four computers were on the Internet. Graphical messages had yet to be developed.

In the late 1960s the Department of Defense began what is now known as the Internet by finding a way to link up the computers of its various contractors and to communicate with research departments at a variety of universities. It was an attempt to determine if there was a way that their computers could "talk" to one another. To accomplish this, the computer scientists who worked for these agencies developed a basic language and protocol as a standard for all the computers on the "network" so that the "talking" would be understood. The TCP/IP (Transmission Control Protocol/Internet Protocol) was the protocol that allowed the "talking." The Internet was designed to be decentralized and open-ended. One motivation for this design was so that in case of an enemy bombing or attack, the communication would not be interrupted. The Internet was designed so that any computer on the network could talk to any other and also route any messages to any of the other computers. These messages were text only. If one of the computers was having a problem, the message could be routed around the troubled area, allowing the message to be delivered.

1970s

By the 1970s, computer scientists had created FTP (File Transfer Protocol), which allowed files to be transferred between computers; Telnet allowed computers at one location to use applications located at another location; TCP/IP was put in place; and email began. Computer Bulletin Boards were established and floppy disks were used as a way to store small files. The first video game, Pong, was invented. Apple, Inc. and Microsoft, Inc. were founded. Hard disks (hard drives) were invented. Between the early and late 1970s the number of computers connected to the Internet rose from 23 to 100.

1980s

By the 1980s Usenet newsgroups were established to share information; CompuServe was founded; ARPAnet was ended; domain name servers

were first introduced; and the National Science Foundation Network (NSFnet) was in place. Europe was connected to a network like the Internet in major European cities. International Business Machines introduced the operating system PC/DOS in the early 1980s, and then Microsoft introduced Windows in the mid-1980s. This new Windows interface followed the lead of Apple Computer's user interface. The number of colors that could be displayed on a computer screen was very limited by the type of color interface card that the user had to install in the computer. The EGA video card (dating from about 1985) could display sixteen colors at 640x350 resolution on the monitor. The 1986 PGA card could display 256 colors on a 640x480 resolution display. Not until 1987 was the first sixteen-color VGA display available on the PS/2 by IBM. To get more colors, consumers had to buy extra color video cards. Microprocessors began to speed up to 25 MHz by 1988. In the early 1980s, Apple gave us its first graphical interface, which showed small picture icons to indicate files. Apple then introduced the Macintosh in the mid-1980s. The earliest of these were black and white until the 1987 introduction of the color MacII. In 1985, Commodore Computer introduced its amazing new computer, the Amiga. This computer could display 256 colors without the addition of extra video cards, and it had built-in animation and sound chips along with dual processing of information and graphical calculations. By 1987 Apple Computer introduced HyperCard as an interactive hyperlinked medium. In 1989 QuickTime movies were introduced by Apple Computer. By now the number of computers connected to the Internet went from 100 to 100,000 with a top speed of a 14.4K modem.

1990s

America Online (AOL) was founded in the 1990s. In 1992 NFSnet allowed the first commercial use of Internet, with Pizza Hut taking its first orders on the Internet in 1994. In 1992 physicists at CERN, a European physics laboratory, invented the World Wide Web (WWW). The invention of the WWW was based on a hypertext protocol called HTTP (Hypertext Transfer Protocol). In this protocol, text could be linked to other text with a click of a button on a mouse or by selecting enter key on a keyboard. The language that came out of this protocol was Hypertext Markup Language (HTML). The early browser Mosaic was created in 1993. InterNIC was created by the National Science Foundation to keep track of domain names.

The Internet Index's Win Treese tells us that on March 2, 1993, Bill Clinton was the first U.S. President to send an email message, and that

the Seattle Public Library was the first to offer its users free internet access in 1994. In 1995 Microsoft came out with Internet Explorer and Netscape Navigator was introduced. That same year, AOL began to offer Internet access. In 1996 WebTV was invented. In April 1997 the Galivan was the first laptop computer introduced, and it was heavy. Windows 3.0 was introduced in 1990; and Windows 95 was introduced in August 1995. We also got the Pentium processor and the PowerPC processors. Computers connected to the Internet went from 100,000 to 10 million at the speed of a 56.6K modem and on fast T1 and DSL lines.

Although it hasn't been in existence for very long, already vast uses for this technology have been developed and are in place. Business has found a new frontier for growth on the web. During the 2000 Super-Bowl XXXI, almost all of the advertisers had a .com address and many were Internet providers of some sort. The advertisers were such companies as Monster.com and Hotjobs.com. So, it isn't a surprise that in 1999, many hundreds of American households joined the Internet each hour.

HOW THE INTERNET AND WEB WORK

WHAT IS A BROWSER AND WHAT DOES IT DO?

A web browser is the software that allows you to see what is found on the Web. It translates the HTML code, animations, text, graphics, sounds, and all the other objects served up over the Web into what you see on your screen. It is the intermediary between the server and your personal computer. The most commonly used browsers today are Microsoft's Internet Explorer and Netscape's Navigator or Communicator. These similar pieces of software are competing for their marketshare of computer users on line, and this competition makes them constantly upgrade their products to better deliver the content that appears on your web pages. If they don't upgrade, they stand to lose users of their product.

When your browser opens up and connects to the server computer, it receives a command from you pointing to where you wish to go. A request is sent to that computer along the infrastructure of the Internet asking for the connection to be made and then for specific pages to be served to you at your location. The HTML, JavaScript, XTM, and so on will tell the browser how to display the page and what actions to take. It will request that a specific image is displayed in a specific location on the page and that specific buttons are placed where they belong. These buttons have specific actions attached to them and the browser asks the HTML code to tell them what those actions are and where the buttons lead when clicked.

Sometimes buttons don't work. Sometimes graphics don't load. When this happens, it means that there is either an error in the code or something is missing in the server folder, causing the error. In the case of missing graphics, often the image file is misplaced so that the pointers telling the server where to fetch the graphic and place it on the page are not pointing to the correct location. The cause could be as simple as the name of the graphic is not exactly the same thing as it is in the code. It could be as simple as having the graphic in a separate folder inside the server and not making that clear in the code.

Since many newer web development programs will generate the code for you, this is becoming less common. Occasionally, it can still happen when the website developer forgets to upload the image file or misplaces it. So, when you see the broken graphic file, it usually means that the image was not sent to your browser window to be viewed.

WHAT IS A SERVER?

For our purposes here, a server is a powerful computer with larger capacity than most users' desktop machines that is designed for large-scale networking. This computer usually resides at your Internet Service Provider or ISP. This server holds the users' web pages and websites. The server also provides access to the Internet for the subscribers who usually pay a monthly fee. It also sends routed messages and commands on the Internet to and from your home computer. This server operates using Internet protocols so that the information transferred is readable at the receiving computer. The server has an address that exists in both numbers and as a domain name. These addresses tell the message where to go and also where to retrieve information.

Computer users can subscribe to an Internet service for a user fee. Usually, there is a monthly fee for access to the Internet and email service. Common Internet providers that sell their services for a fee are America Online (AOL.com) and Earthlink (earthlink.net). Many telephone and cable TV companies are also offering Internet connections.

WHAT IS A DOMAIN NAME?

A domain name is part of the Internet address. Domains are for categories such as universities, businesses, networks, military, government, and organizations, as well as others being developed. These categories are represented by a three-letter designation after a dot. Universities use .edu; businesses use .com; networks use .net, and so on.

Anyone can register for a domain name for his or her website. However, you must fit the category to be able to use certain designations. In order to receive permission to have a domain name, you must

do a thorough search through the central organizations that register these domain names to find a unique available name. Only one person or group may have any one name. If I wanted to have the name art.com for my domain name, my first step would be to do a search at the central register through any search engine to see if anyone already has registered that name. If not, then I can reserve it and pay my fee to register the name with an intermediary offering the service through the search. If someone else has the name, I cannot use it. The ".com" is the most used designation by single persons and businesses. So, if I were to be able to get the "art.com" for the domain name, I would have a web address or URL of *http://www.art.com*. If I had that domain name, I could have an email address of *houghton@art.com*.

You do not have to have your own domain name to have a website. Most Internet Service Providers (ISP) give their subscribers allotments of space on their servers to build their websites. The address of this kind of website would use the server's address with a pointer to that website. So, my website on my server at school is *http://www.nku.edu/~houghton*. This tells the potential visitor that my website is located on the server at Northern Kentucky University in a folder or account called "houghton."

BASIC WEB DEVELOPMENT

You are familiar with what websites look like. You have made decisions about what you would like your website to look like to communicate to others. Now, you need to know how it all works. We will not go deeply into the writing of the Hypertext Markup Language (HTML), but we will look at it closely enough to show you how it works. Many of the newer web development programs make writing HTML code from scratch unnecessary. However, if you want to do fancier stuff with your web pages, learning how to write code may be just the ticket for you. Along with HTML code, there is a scripting language called Java that allows web developers to animate pages with text or images that change when you roll over them or with images that move and do a variety of other things. Before we begin to define all the terms used in web development, to give you an overview, I will give you a short assignment.

Short Assignment: Open any web page in your browser and go to the menu item **View** and select **Source** or **Page Source.** This will show you what HTML looks like. In both Internet Explorer and Netscape, a new window will open with the code showing. Now look back and forth between the page and the code to see where things are and how the code is

written to display the page. I don't expect you to understand this completely, but you will notice that there are things like <head>, and when the header is ended it says </head>. At the beginning of the title it says <title>, and after the page title is written out in real-life language it says </title>. At the beginning of a paragraph it says <p>, and at the end it says </p>. This tells the computer that there is a beginning and ending for each command given in this language. It takes a lot of work to write HTML code. A few years ago, HTML coding was the only way to construct a web page. Some programmers and developers still write code.

Notice how pictures are referred to on these pages. There will be followed by <img src= then in quotes the location and name of the image followed by an to end the command. This tells the browser where to find the image to insert and where to put it on the web page. Without all of these coded commands, the browser would not be able to display the information requested. When you see a page in your browser with a broken image icon, it usually means that the coded information was not correct, was corrupted, or the image was not where it was supposed to be.

BASIC HTML OVERVIEW

Because the HTML file is a text file only, it is really very small compared to the graphical file. The images used on the page are not contained in the HTML file. They reside on the server, but are referred to by a tag in the HTML file. When the page is called up, the HTML file is read, the tag sends a message to the server to send the image file and you see it on your browser. Its location on the page is indicated in the HTML file.

PARTS OF THE HTML PAGE

The HTML page consists of two parts, the head and the body. The head section of the page contains the specific page information such as its title, the metatags defined as the keywords that are necessary to be able to find this page in a search, any copyright or image map information, or, often, information about the program that created the web page. The body section of the HTML page contains all the other information that you have placed on your page. This might include graphics, text, buttons, backgrounds, tables, and any other element that you have placed there.

BASIC TAGS USED IN HTML PAGES FOR TEXT DISPLAY

Remember that the tags tell the browser to do specific tasks. These tasks might include showing the text in a certain color, showing the links, or getting and then displaying the images in a certain place on the page. They also create page layout. Tags are used in pairs with one at the

beginning of the section to be tagged and one at the end of that section telling the browser to cease and desist applying that tag to the rest of the text. They look like this: <p> to begin a new paragraph and </p> to end that paragraph. These basic tags are:

<p> Paragraph break.

 Line break; new line, but not using extra space like when you do a paragraph break.
<br clear=all> Line break; new line, but with the margins cleared. If you had a section of text centered before you used this, the next section of text would be flush left, not centered.
<center> Centers the text on the page.

Then there are tags for the text to give it style—but remember to use the ending tag to indicate where you want that style to stop being applied.

 Makes the text bold.
<i> Makes the text italic.
 Makes the font larger. Use increments of 1 to increase the font size.
 Makes the font appear in Times typeface.

To create a list of items for your web page, there are also simple tags:

 With the first item
 With the second item and so on until you want the list to stop. Then add a after the last item.

To create a simple list with bullets, you would put a on the line before the first and a after the last item and before the .
Once again, remember that each time you use a tag to tell the browser to do something, you must also tell the browser when to stop doing it by placing the end tag of </tagsymbol>.
You can find out much more about HTML scripting by accessing the NCSA *Beginner's Guide to HTML* at the University of Illinois Urbana/Champaign at *http://www.ncsa.uiuc.edu/General/Internet/ WWW/HTMLPrimerAll.html#GS*. This primer will show you how to

use and how to write HTML and will give you more information about how to use basic HTML for web development. There are also more advanced links from the site and discussions of the latest developments in web technology and languages. Use of the information on this site is free but limited to educational and nonprofit purposes. Many colleges and universities have links to this site from their own web development pages because of the valuable information found here.

JavaScript is a general purpose programming language designed to let web developers and programmers with a variety of skill levels control the behavior of software objects or elements in their web pages. The language is commonly seen in the use of web browsers whose pages have more interactive and dynamic appearance. This language can be used in browsers, web creation programs, and also Adobe Acrobat, to cite a few places. JavaScript as used in HTML documents for the Web is embedded within the HTML code with the tags and content.

JavaScript was developed at Netscape by Brenden Eich. A language closely related by name, if not by some commonly used syntax, is Java. "Java is not JavaScript and JavaScript is not Java," writes Danny Goodman, a master of JavaScript and computer expert. JavaScript cannot create applets, which are small applications that run within software programs or standalone applications. *Java,* developed by James Gosling at Sun Microsystems, is a cross-platform language and environment. JavaScript can be considered an extension of your HTML script. It allows you to incorporate other processes into your page. JavaScript is object-based scripting language for use on your computer and for server applications. JavaScript lets you create applications that run over the Internet. Client applications run on a browser, such as Netscape Navigator and Internet Explorer, and server applications run on a server (the server is your Internet provider.)

One of the most commonly seen JavaScript embedded uses is the *rollover element.* The visitor moves the mouse over an element such as a button or some text, causing a change in the element. It might glow, change color, change size, move, change image completely, or some other visible change will take place. These rollovers are used to give the visitor the clue that this is an active linking button or provide text that will take them to another place in the website or on the page. Using JavaScript in the Web has made pages were more active and more interactive.

JAVASCRIPTING

Functions are one of the fundamental building blocks in JavaScript. A *function* is a JavaScript procedure—a set of statements that performs a specific task. A function definition has these basic parts:

- A function keyword
- A function name
- A comma-separated list of arguments to the function in parentheses
- Statements in the function in curly braces

It's important to understand the difference between defining and calling a function. *Defining the function* simply names the function and specifies what to do when the function is called. *Calling the function* actually performs the specified actions with the indicated parameters.

You can use JavaScript to change the color or size of type or add a shadow when the mouse cursor is rolled over it. This dynamic change in the HTML page uses a simple JavaScript that shows the rollover image in the script.

NEW TOOLS FOR ADVANCED WEB DEVELOPMENT

Because technology is moving at a rate that is almost incomprehensible, we need to be running to stay even. Products and programs are already outdated when they appear on the market, because the developers are already moving on to the next generation of the tools. From those ideas spawned while working on these highly creative approaches to communicating with code, wonderful new developments occur and grow into new consumer programs. Because of this, we could consider that when we use a program, its developers and programmers are light years ahead of us in their thinking, working daily to bring us still better and newer ways of working with the web. Compared to programming and designing software, the job of designing pleasing visual and informational websites is easy. We expect the developers to free us from the extreme hard work of making our images look good and writing or devising the code.

What we do as artists, designers, and communicators is as important as, but different from the work of the software developers. Our job is to use these tools in the most creative ways and to point to places where developers must work to make the tools better. From the early clunky days of having to write code to have anything appear on a text-based simple internet interface about fifteen years ago to the stuff that is appearing in the next generation of development, many good ideas have

come and gone along with entire programs, companies, and threads of development.

Most of the graphical programs used on the Web have been raster and bitmapped image based. Raster images are lined like the scanning pattern on a TV screen or monitor. This means that the quality of the image must be reduced to make it small enough to open on the visitor's computer screen at a rate that is reasonable, given the speed of the modem or cable used in the visitor's location. These images and pages appear fine on the computer screen but when printed on paper they are less than perfect. When these images are downloaded and printed, they are broken up, not clear, and the text is either pixelly or only very basic fonts are available. Pure HTML language is rapidly moving from being the only way things were done to being only a small part of the language of the Internet. HTML has gone through a variety of upgrades that have allowed it to act more dynamically by allowing interactivity to increase. JavaScripting language and other improvements in activity allow the viewer of websites to see moving images, rollover images, and a variety of other engaging interactive elements.

The world of the Internet is changing so rapidly that we are at a loss to even imagine where we will be in a few years. Not long ago, the introduction of even simple sound was an effort; now we can download and play music videos with MP3-encoded sound and full streaming video. Digital video and digital sound are becoming commonplace when only a very short number of months ago both were for the elite with large capacity computers and the fanciest of modems or cable connections. Now almost any home can have a high-speed line through its phone or cable company, and even your car can get the Internet connection through the air. The sound and video revolution in the Web is commonplace now—this has taken less than one year. Where it is all going is exciting, but this also means that anything we learn in terms of programs will be short lived and a stepping stone to the new development that lies ahead. This notion can either overwhelm creators of web content or we can look at it as developing our vocabulary in a lifelong learning process.

If we, the artists and designers, choose to work in the world of computing and the Internet or web development, then we are going to be on the fast track where each program will only lead to the next. We will leave other artists in the dust, so to speak, because development in other media is much, much slower. Certainly there are new glazes in ceramics; new kilns and methods of working are constantly undergoing changes and corrections. But the pace in other media is so much slower

and therefore understandable. In other visual arts, people can use tried and true processes and produce work that is visionary without having to constantly learn whole new ways of working and thinking about working. In other disciplines, artists can hone a vision that is distinct, finely tuned, and personal over years of working within a specific method and process.

However, if you choose to work with the Internet and Web as your medium, don't expect to EVER move at a leisurely pace. There will never be a moment of rest for you. You will always be running to stay in place or you will quickly resemble a relic. At times, you will have to learn whole new ways of working on the Web in a matter of months. Every once in a while, however, you might get as much as a year to work on your favorite program before it is upgraded or scrapped altogether.

Actually, those of us who have used the computer as an artmaking device for years have been able to work on one or another variation of Adobe's Photoshop. I began using version 1 on a computer in the lab at the university. When I bought my first scanner it came bundled with version 2.0. That was back in the late 1980s or very early 1990s. Here it is, just after the change of the millennium, and I am still using Photoshop, but it is more sophisticated and I still don't know the entire program because for my way of working, I don't need the entire thing. I have had time to build my skill level over a very long period of time in the computing world.

With the Internet, my favorite program, Adobe Imagestyler, has become obsolete. It was the best of the bunch, in my estimation. Certainly, it had its limits in that the images looked dreadful when printed out. But for me the Web is the medium of the monitor and not the printed page. Its shortcomings are clear in the way it handles text and in the fact that you must move to another program to add forms. But because of its ability to make my pages look wonderful and because it worked a lot like Photoshop, my real love, I was happy as a clam to be able to make my web pages in a mere few minutes and get them up for my audience to see. I am faced once again with a whole new learning curve and I only have an inkling where the curve will be. This is the future for all of you who wish to make your place in website creation, whether for your own creative purposes or for commercial ones.

SVG and the W3C

The World Wide Web Consortium (W3C) is developing a new standard called Scalable Vector Graphics (SVG) format, which will revolutionize the way we process graphical information for web pages. While

SVG is in development and in its early stages, the changes in how graphics are handled within the HTML environment should be stunning. Scalable Vector Graphics will differ from what we have been using—bitmap formats such as GIF, JPEG, and PNG that contain a description of every pixel in any given image. This makes for large files sizes, which in turn slow down the loading of images onto web pages. The new SVG format will allow for faster downloading of information, because in real text it describes shapes and paths rather than each pixel of the image. Describing the shapes and the paths that the shapes take can be done more efficiently, which will therefore speed up the time it takes to load the information.

With SVG, the same image information, once described, can be reused and not described again. Your web page design would tell the browser to draw a shape over there and then again over there on the page. SVG is based on the XML (eXtensible Markup Language), which is text based and efficient. It will fully integrate with the present standards of HTML, CGI, and Java. It is, in its own way, similar to PostScript language, although PostScript is large in the way it describes scalable fonts or images. If you are familiar with PostScript fonts, you know that they are completely scalable.

With SVG, the promise of that kind of sharpness is there at any scale and both in print and on the Web. This, in itself, is revolutionary. Most designers would have to design one set of graphics for the Web and another for print because printing from the Web was uncrisp and mostly unacceptable to the commercial world. The added costs of doing both web and print graphics often meant hiring a web designer and a print designer because they often had different sets of skills. Not all graphic designers were good at web design because web design approached the information in a very different way. Until recently, graphic designers were not trained to work with the limitations of the Web.

URLs Used in This Chapter

- NCSA *Beginner's Guide to HTML* at the University of Illinois
 http://www.ncsa.uiuc.edu/General/Internet/WWW/
 HTMLPrimerAll.html#GS

2

EXPLORATION
OF THE
INTERNET
FOR
RESEARCH

The Arts & Crafts Society website at www.arts-crafts.com.

THIS CHAPTER WILL look at the Internet as one of the resources students can use for research. However, the Internet should never be the only resource; it should never replace going to the library to find the books for the information you seek. You may want to use the Internet to point you in directions that you can follow up with research in the library with primary or secondary sources. In this chapter, you will also be introduced to the variety of means to find out information through search engines or indexes. You will learn how to save your source URLs on your own disks for personal use. You will learn how to bookmark your favorite web pages.

I will begin by stating the obvious: The Internet is a vast web of interconnections that link databases, informational sites, sounds, and images worldwide through a variety of computer links or data traveling on a variety of conduits in and out of computers on your desktops, in offices, in universities, in research labs, and about anywhere you can imagine. Gertrude Stein once said "There is no *there* there," and, as many who are familiar with the structure will tell you, the Internet is the same. This flow of data seems so effortless for most users that they never stop to consider how or why it all happens.

If you can imagine a time before any of this was generally available, then you can imagine how mindboggling it all is for many older folks to behold. There was a time, not that long ago, really, when I got my first computer and couldn't really even imagine how I would use it to make art or for much more than to make typing easier and more reproducible. Now I live in a world where I cannot imagine a day when I don't sit down at my computer to check my e-mail or look up some bit of information on the Internet. The tool of the computer is as important to me as a knife and fork at the dining table or a pencil at my studio desk. We now take for granted that we will need to use the computer regularly in daily life. We take for granted that we will be able to look on the Internet to find the best price for some object of our desire. We also expect that we will be able to correspond with our friends and relatives elsewhere in the country to save the cost of a long distance call. The use of the Internet and email have begun to teach us to write again, even if only in short stream-of-consciousness-type notes. For many, the computer has reintroduced them to the written word. Students take it for granted that they don't need to make so many trips to the library to use the reference books because now they can research information for their assignments on the Internet and never leave the comfort of their own bedrooms or family computer rooms. However,

as they will discover, the information on the Internet is not always as reliable as the information they find at the library. By going forward, we have returned to our beginnings.

The computer has also taught us to be more visual in our connections. When we move about or "surf" the Web, we find that those sites that are visually more interesting will get us to stay a bit longer than our shortened attention span usually allows. We find that when we visit sites with too many advertisements and too many swirling and jumping objects, we want to leave in much the same way that people fled the hawkers and barkers in old shopping areas. No one really wants to be screamed at. We want the peace and quiet of our own private space to track down our information. We want that space to be beautiful to look at and intriguing to spend some time in. And we want it so intellectually and visually exciting that we can't wait to explore further or return again and again.

Life without the computer now is hard to imagine, so we will find ways to use this machine of our future to the best of our ability and for the many purposes. The computer is also the tool of lifelong learning. With the introduction of small portable computers, Palm Organizers®, wireless hookups, and the like, we can be connected anywhere we go in almost every activity we can imagine. We now only have to decipher the information given back to us and decide what is useful and what is not necessary for our quest. According to Douglas Rushkoff's (1994) book, *Cyberia, Life in the Trenches of Hyperspace,* this is how it begins:

For example, many of these computer programs and data libraries are structured as webs, a format that has come to be known as "hypertext." To learn about a painter, a computer user might start with a certain museum. From the list of painters, he may select a particular portrait. Then he may ask for biographical information about the subject of the portrait, which may reveal a family tree. He may follow the family tree up through the present, then branch off into data about immigration policies to the United States, the development of New York real estate, or even a grocery district on the Lower East Side.

SEARCHING THE WEB FOR INFORMATION

The World Wide Web is a part of the Internet, but it is not the Internet. The Internet is the structure of computers and hookups. The Web is the data flowing freely on the Internet. Searching the Web will bring you such vast mountains of information that your diligence is required to separate what is necessary from what is not. In order to search, you will need to visit *search engines.* There are a variety of types of search engines. Some are really organized listings or directories; others ferret out

information for you. Some find information by using keywords, which are the most obvious words you can think of when you consider a certain subject. A partial list of common search engines is: AltaVista, MetaCrawler, Excite, HotBot, Lycos, Yahoo, InfoSeek, Snap, and Ask Jeeves!

Here is an example of something to find out about: Let's say you are interested in how Rembrandt used light. You could look for Light, but the information would be so vast that you might never find Rembrandt in the listings. If you look for Rembrandt, you will also find vast listings, but you still might not find anything about light. If you look for the words Rembrandt and light, you will find information on all uses of the name Rembrandt and information on Rembrandt's use of light and lights. You have to sift through all the information you find to get to what it is you are looking for in particular. Looking through all the information you can raise from the search engine will take a lot of time. So searching and how to search is the issue here.

When I looked up Rembrandt on MetaCrawler, I got four long pages of links with 73 matches. AltaVista found 46,080 matches with references on twenty pages of links to Rembrandt. Excite came up with 12,668 matches but some were for Rembrandt toothpaste. HotBot had more than 10,000 matches. InfoSeek had 14,076 matches. Lycos had only 8,505 websites identified as matches. When I put in Rembrandt van Rijn, MetaCrawler gave me three pages of links with 53 matches. AltaVista narrowed it down considerably from 46,080 to 2,448 when I asked for Rembrandt van Rijn. How you search will change the results that you get back from the search engines.

Not all search engines are the same or use the same devices to search. One of the search engines that seems to best use the question format is Ask Jeeves! or Ask.com. In this search engine, you will type in your question or key words and Jeeves will bring up information from many other search engines. Here it is in Jeeves own words:

CALL ME JEEVES. I don't know if you've received references about me already, but I have the strongest feeling that you'll delighted I'm introducing myself now. Indeed—and I hesitate to toot my own horn—I'd wager a fair amount that by the time we're done here, you'll be chanting "Jeeves, Jeeves, Jeeves. . . ." Don't, though. It's unnecessary and it's excessive. Knowing I've helped you is its own reward.

In short: I am here to serve you whenever you have a question that needs to be answered.

Any question. Every question. Small questions. Large questions. Hard questions. Dumb questions. Important questions. Frivolous questions.

I've spent the last several years perusing the Internet, uncovering wonderful sites that will help simplify your life, help you with your homework, find information for your business proposal, help plan your much-needed vacation, find that fun site that you need to help take your mind off of everything. Why has Jeeves done this, you ask? So you don't have to.

But I haven't even told you the best part yet: I speak your language. When you ask me a question, you type it out just the way you would if you were talking. No "keywords." No "search strings." No "Boolean" nonsense. Just plain old English.

I then go into my vast knowledgebase of sites—that ever-expanding collection I've been gathering for years—and pluck out the very best of them to answer your question.

Am I perfect? Of course not. (Is Jeeves being rude to ask if you're perfect? Of course not. Who is?) In order to round out my search, then, I also avail myself of those lumbering, periodically helpful beasts: the conventional search engines. So while I search my answers, the other search engines scour the Web for you. Within seconds, you'll have before your eyes not only my handpicked recommendations, but also their broader ones.

So not only will you get the best results, you'll also get complete results—and all with one click! (For all the time that Jeeves helps you save now and in the future, might he recommend that you use it to do something else you love—gardening, playing catch, reading a book perhaps?)

Now…May Jeeves lead you through this simplest of processes?

First, type your question in the box below.

Second, click on the "Ask!" button.

End of tutoring session. Finito. Done. You're on your way. A tad less complicated than trying to hook up your stereo, no?

Indeed, perhaps your greatest difficulty will be deciding what you'd like to ask. (So much information out there, so little time.) If you need a little kick-start, please visit "Popular Questions" and take a gander at a list of the most popular recent questions. Or visit one of Jeeves' special areas, like health, money, etc., where you can view the vast array of questions that Jeeves can answer for you on that particular subject. Jeeves is willing to wager that you'll come across quite a few questions that you'd love to have answered.

So go ahead and ask Jeeves a question!

When you look on other search engines, such as AltaVista, you get some of the same results as you got on Ask Jeeves, but you also get many others. Because Ask Jeeves uses a variety of search engines and real word recognition, it will give you a cross-section of results. Those results do not go very deeply into the search engine's holdings, however. When you use the search engine Google, you need to give it words, not sentences, or you will go to very peculiar places. You can

also do advanced searches by telling the search engine, "yes" to certain types of information and "no" to others. Doing this involves using the "Boolean operators." This means you can be more specific in what you are looking for to find the results. It means that you may want only the pages with exactly the information you are looking for and not pages with only some of the information. Using Google's advanced search allows you to search for pages that contain specific words or phrases and exclude pages that contain other specific words or phrases.

Definition of Boolean: Of, relating to, or being a logical combinatorial system (as Boolean algebra) that represents symbolic relationships (as those implied by the logical operators AND, OR, and NOT) between entities (as sets, propositions, or on-off computer circuit elements). <Boolean expression> <Boolean search strategy for information retrieval>.

Other search engines generally work in the same way. Then there is Yahoo. Yahoo is often thought of as a search engine, but in reality it is not. Yahoo is an index or directory rather than a search engine. The founders of Yahoo say this about their site's history:

What began for us as a fun way to collect our favorite sites has blossomed into a network of directories and features and news feeds, including everything from driving directions to sports scores, from live chats to the latest in online shopping. You can follow your stock portfolio online everyday. You can get weather updates for practically anywhere in the world, find old friends you haven't seen since grade school, download the latest games, get personalized news, place free classified ads, meet new friends . . . and the list goes on.

Short Assignment: Compare search engines and indexes by doing a search for the same thing on five different search engines. Compare whether the searches give you the same results. See what happens if you give a search engine more specific information about what you are looking for by adding one or two other words to your search query.

Short Assignment: Follow the instructions below and create your own disk for saving personal **Bookmarks** or **Favorites.**
Once you have found information that you want to have readily available for use at other times, you need to use your browser software to bookmark or save it as **Favorites.** This simple process has your browser save the URL location in a list for your easy retrieval. If you look at the menu bar on the top of the window of your browser, you will see either **Favorites** or **Bookmarks.**

BOOKMARKS

*Microsoft Internet Explorer **Favorites** menu showing **Add Page to Favorites**.*

*Netscape's **Bookmarks** menu showing **Add Bookmark**.*

When you scroll down under either **Favorites** or **Bookmark,** you will see a command to add either one to your list. You can then retrieve any of them at any point from the list that will form below in that menu item. You will be able to organize your **Bookmarks** or **Favorites** in any fashion you desire.

SAVING YOUR BOOKMARKS TO USE ON A DISK

The problem with this is that if you work on a lab computer, as you would at school, how can you save these **Favorites** and **Bookmarks** for use when you go home to your own computer? One easy way to do this is to go to the **Bookmarks** or **Favorites** menu item and simply drag the saved **Bookmark** or **Favorite** to your own zip or floppy disk. Another way to do this is to select **Organize Favorites** or **Edit Bookmarks** under the **Favorites** or **Bookmarks** menu item. This will open the list of the

*Internet Explorer **Favorites** menu showing **Organize Favorites**.*

*Netscape Navigator's **Bookmarks** menu showing **Edit Bookmarks**.*

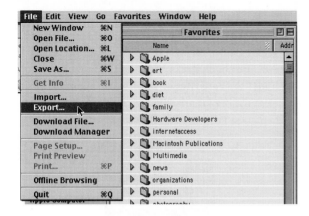

*This window shows the Internet Explorer **Favorites** brought up from the **Organize Favorites** command in one window and the **Export** command under the **File** menu. Exporting will let you save your **Favorites** as new file on your zip disk.*

bookmarked items. Then use the **Export** command under the **File** menu and you can save all the bookmarks on the computer you are using into a folder. When you wish to use them on your own computer or another lab computer, import them using the command under the **File** menu.

*This window shows the Netscape Navigator's **Bookmarks** brought up from the **Edit Bookmarks** command in one window and the **Save As** command under the **File** menu to export the **Bookmarks.** Exporting will let you save your **Bookmarks** as new file on your zip disk.*

Remember to clean your bookmarks off the lab computers when you are ready to leave the program. This is good etiquette, highly favored by lab technicians.

To clean off your bookmarks go to the **Organize Favorites** or **Edit Bookmarks** under the **Favorites** or **Bookmarks** menu item. Once the list is open, select the bookmark you wish to clear by clicking on it ONCE and then go to **Edit** menu and select **Clear.**

Edit menu in Internet Explorer with the ***Clear*** command selected so that you may clear off all of your saved ***Favorites*** from the computers in the school lab.

Edit	
Undo	⌘Z
Cut	⌘X
Copy	⌘C
Paste	⌘V
Clear	
Select All	⌘A
Get Info	⌘I
Find in Bookmarks...	⌘F
Find Again	⌘G
Preferences...	

Edit menu in Netscape with the ***Clear*** command selected so that you may clear off all of your saved ***Bookmarks*** from the computers in the school lab.




USING WHAT YOU
BOOKMARKED




Once you have saved your bookmarks, you will want to use them for a variety of reasons. If you decide to include information from the bookmarked source in a research paper or on your website, you are, in fact, publishing it. You must note the source and get permission for copyrighted material. The standard bibliographical format should be used




CHAPTER TWO

for written material and a clear note should be placed on websites that use or refer to someone else's original material.

Remember that when you post something onto the Web, there are some legal questions about fair use that arise when the material applies to research, education, and scholarship. When you are using material for profit, you must have permission to use it. When you are quoting a small section of something written, there are fair use guidelines you should follow. The safe thing is to always give credit to your source, use primary sources whenever possible, check copyright dates to see if the work is now in the public domain, and **get permission from the source.**

Four factors are cited by the Library of Congress for fair use for education:

1. The purpose and character of the use, including whether such use is of a commercial nature or is for nonprofit educational purposes.
2. The nature of the copyrighted work.
3. The amount and substantiality of the portion used in relation to the copyrighted work as a whole (Is it long or short in length, that is, are you copying the entire work, as you might with an image, or just part as you might with a long novel?).
4. The effect of the use upon the potential market for or value of the copyrighted work.

Some sources for finding out more about copyright and fair use on the Web are:

http://fairuse.stanford.edu/
http://www.cetus.org/fairindex.html
http://www.bitlaw.com/copyright/fair_use.html
http://www.albany.edu/~ls973/copy.html
http://www.ninch.org/ISSUES/COPYRIGHT/FAIR_USE_
EDUCATION/FAIR_USE_EDUCATION.html
http://lcweb2.loc.gov/learn/cpyright.html#fairuse

It is hard to decide when reading material posted on the Web whether the author is reputable and knows the subject matter well enough to be reliable. A simple guideline is that if what you find is on a site created by a professional society or is on a scholarly site, it is likely that the information will have been checked. If you come across research material on a personal website, it is much better to double-check the information

**EVALUATING
INFORMATION FROM
THE WEB**

provided with more than one other site to see if it is reliable. You wouldn't want to turn in a research paper full of bogus information that wasn't double-checked because you were not careful.

Just as you don't believe everything you read in the newspaper, don't necessarily believe everything you read on the Web. Because of its anonymity and democracy of operation, anyone can put anything on the Web. A web page can appear to be dependable because of its look and style of presentation, but unless you check out the information in more than one source, don't take the author's word for granted.

It is always best to use the primary source. A primary source is the first source of information. Say you are researching Mondrian's theories about the use of color. His published words would be the primary source, and reading an art historian's interpretation of this theory would be a secondary source. You can find lists like the one here from someone's research. The sources might be good, but be sure to check them out before you take them as solid sources. To check out a source, see if you can find the same information in a few other sources. Make sure one of those sources is a published book.

Mondrian On-Line Resources

This is my collected list of internet based resources, links, and other bits and bobs for the artist Piet Mondrian. If you find any more, please tell me about them. (This list is slowly being updated and corrected, so I apologise for all the errors.)

You will find the following sections listed below:

- Piet Mondrian's Paintings
- Galleries and Collections
- Biographies
- Create Your Own Mondrian
- De Stijl Movement
- Lists of Mondrian Resources
- Miscellaneous Mondrian
- Related Material

There are 139 links filtered from 1862 possible URLs found.

Paintings

- Blue Chrysanthemum
- Blue Rose
- Boxes with yellow and blue #114 (doubtful title)
- Boxes with yellow and blue and red #115 (doubtful title)
- Broadway Boogie Woogie
- Checkerboard with Light Colors
- Composition #3 with Trees (c1912)
- Composition (1921-2)
- Composition in Blue (1917)
- Composition in Blue B (1917)
- Composition in Blue, Yellow, and Black (1936)
- Composition in Grey & Yellow (1932)

Research website: www.fmf.nl/~jeldert/hendrik/mondriaan/resource.html.

When you find images on the Web that you wish to use in your research or your websites, you can download them to your computer by clicking on the image and holding down the mouse button. The image will download at the less than beautiful resolution of 72 dpi. A 72 dpi image has 72 dots of information per inch. Such downloaded images cannot be enlarged without looking very bad. If you include the printed downloads in a paper, you must credit the source of the image in your paper and bibliography. Including them on other websites without major changes to the image will also require giving credit to the source. For work to be considered a major change, you must substantially crop, paint upon, change colors in the image, or use a image editing program such as Photoshop to make the image unrecognizable as the original. **Without doing this, you must get permission to use the image and also credit the source.**

Short Assignment: Copyright and Fair Use: Using two search engines do a search for copyrights and the visual arts, fair use and copyrights, and copyrights. See what the sources have to say and see if they say the same thing. Evaluate the information to see what is relevant to your purpose and what is not. Make printouts of the most relevant information and keep them in your files for use as reference for your later assignments.

If you use any materials that are copyrighted in your own creative or research work, use these guidelines to prepare your work for either publication on the Web or in hard copy form.

ONLINE ARTISTS' COMMUNITIES

Many artists' groups have created websites for their communities. These websites offer a range of information about the artists, their work, processes, theoretical information, and more. These communities might be tied to professional societies or galleries. Some may be involved in the sale of the work of artists who belong and also might be a venue for exhibitions and representation; others may be artists' organizations for political or social change. Jeff Gates has been the force behind the Art FBI and has created a very interesting website that examines at how the media looks at the artist.

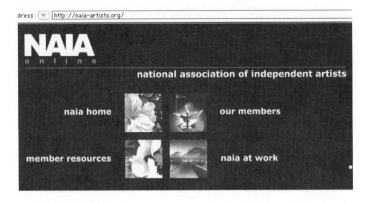

Artists' Community website at naia-artists.org/.

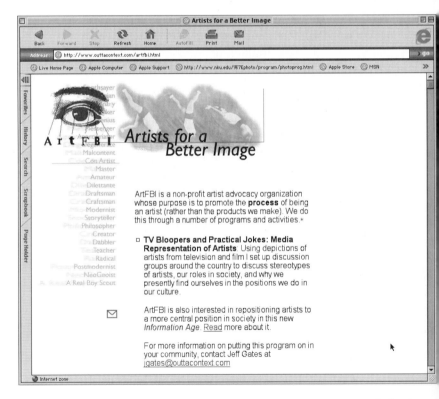

Jeff Gates' website for the ArtFBI at www.outtacontext.com/artfbi.html.

Connect to art sites on the web. Add your web site for free!

Chat Room:
Talk about art, life, or the life of art.

Upcoming Events:Locate exhibits, fairs, festivals and openings near you. Add your event for free!

ARTicles:
Read the latest articles, reviews and advice.

COMmunity

Classifieds:
Find it or post it!

Museums:
Links to museums form all over the world.

Art Mecca's Community Page showing its links at www.artmecca.com/ ArtMecca02/Community.

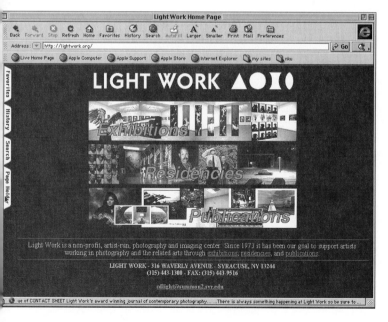

Light Work's home page at lightwork.org.

Art Mecca is a site that sells work and also pulls together features like the Community that has chat sessions, articles archived, events, museum, and other links. Light Work at Syracuse University houses the Community Darkrooms. They run residencies, hold exhibitions, and publish books on photography. This site has links to technical information on photography as well as links to art photography. During Light Work's twenty-five years of existence, it has evolved in its services to the field of photography.

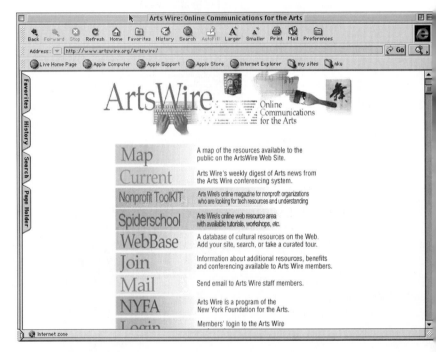

ArtsWire, one of the first Web resources for the Arts at www.artswire.org.

ArtsWire is one of the earlier online art resources with links to many other sites. It provides invaluable information for artist groups, nonprofits, and artists in general and so very much more. Another one of these early sites was ArtSource.

TABLE OF CONTENTS

ARCHITECTURE RESOURCES	ART and ARCHITECTURE PROGRAMS
ART and ARCHITECTURE LIBRARIES	ART JOURNALS ONLINE
ARTIST'S PROJECTS	ELECTRONIC EXHIBITIONS
EVENTS	GENERAL RESOURCES
IMAGE COLLECTIONS	MUSEUM INFORMATION
NEW MEDIA	ORGANIZATIONS
VENDOR INFORMATION	SITES ADDED IN OCTOBER

Welcome to ArtSource, a gathering point for networked resources on Art and Architecture. The content is diverse and includes pointers to resources around the net as well as original materials submitted by librarians, artists, and art historians, etc. This site is intended to be selective, rather than comprehensive.

ArtSource is an extensive website for research across media at www.ilpi.com/ artsource.

Short Assignment: Discipline Search: Spend the next 45 minutes going to one or more of the sites shown in this chapter and make notes about what is interesting to you and helpful information that is provided on each of the sites. Make your own bookmarks for places you will explore or return to in the future. Save them on the disk that you created earlier in this chapter. Use these sites to lead you to other reference sites in your own specific discipline. Where are these sites? Note the URL for each of the sites you have located from these places.

URLs Used in This Chapter

- Arts & Crafts Society: *http://www.arts-crafts.com/*
- National Association of Independent Artists: *http://naia-artists.org/*
- ArtFBI: *http://www.outtacontext.com/artfbi.html*
- Art Mecca: *http://www.artmecca.com/*
- Light Work: *http://lightwork.org/*
- ArtsWire: *http://www.artswire.org/*
- ArtSource: *http://www.ilpi.com/artsource/artsourcehome.html*

3

COMMUNICATION
AND
NAVIGATION:
Designing Your Website
for Best Results

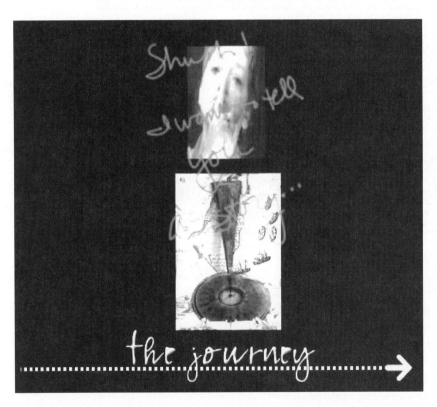

Opening page for exhibition website for the journey *at www.nku.edu/~houghton/journey/journey1.html.*

T HIS CHAPTER EXAMINES the way you communicate effectively with your website. It will look at the preliminary steps necessary in planning the site to communicate the information that you want your visitor to understand. It will show you how to construct a site plan that defines the flow visitors will take through your website.

THE SITE PLAN

The main reason for having a website is to communicate information about yourself, your business, your artwork, or other things to someone else. Clear communication is the goal. As you begin to plan the site, you should make a list of the important ideas that you wish to communicate to others. You will use this list to make your simple site plan. Once you have made this list, decide if each of these ideas will have its own page or set of pages.

An excellent way to do a preliminary site plan is to transfer all of your ideas for pages to self-stick notes and then stick them onto a large board. This will help you to visualize the flow of information from one page to another. Once the notes are in place on the board, decide which pages will have connections or "link" to others and draw arrows accordingly. Decide if your flow of information will be circular or not. If you are doing a circular linkage, then decide where that will take place. Some sites lead you back to the beginning from the last page. Some sites lead you back to the beginning from each page. Some sites give you multiple choices from a variety of pages. Some sites use a set of navigational buttons that appear on each page leading to every other page or group of pages. Ask yourself if you want to let your visitor send you email from your site and how many places you might want that choice to exist. Also, do you want to give yourself credit for designing your web page and use that link to solicit the business of web design for others? If so, make a link to pages for that service.

Remember that nothing is set in stone at this point—you are only trying to establish how you want your visitors to navigate through your website. Once you have the major pages decided, you can place links to less important information, enlarged images, and other websites on your site plan. Make notes all over your plan so that when you are actually making your pages, you can refer to your original ideas for clarification.

The next thing to accomplish is to make a list of what you need to assemble to be able to make these pages.

- Are all of your images web-ready? If not, are you fairly clear on what you will need to gather? You can make placeholders for the images you don't have yet.
- Do you know what text needs to be written? If not, do you have an idea what text you will need and how you will get it—whether you write it or get if from another writer?
- Do you have to research further to find links to related information that you want to be able to access from your website? If not, can you at least make a list of what you will be looking for out on the Web and save that task for later or assign it to a co-worker to do?
- If you do not have any of this material, you have to make or gather the images, write the text, and gather and organize the research so that you can begin.

Every last detail does not have to be tied down at this point. What you are trying to do is to give yourself an overall picture of what you think you want your website to tell others, and also what you want your website to look like. You are also beginning to consider how you want that information disseminated.

Begin to think of how you will indicate the flow of information from one page to the next. How will your links be made? Will you use images, arrows, buttons, or combinations of these things? Will those items sit on a navigational bar? Will you make things a certain color to indicate that they are buttons or navigational links? Decide on your navigational plan. Do you want the same navigational bar or set of buttons on each page? Do you want them to look the same on each page? How will you indicate their function? Some folks get so esoteric that you cannot decipher easily that the button with a certain swirl means forward or backward. You must make this obvious to the visitor. How will you do this?

Now, let's take a look at a site plan for my exhibition *the journey*. This site plan is circular, in that it has pages at the end of the plan linking back to the beginning page. I open with the main page, which links to a text page welcoming you to my exhibition. This links to a continuation of that welcome, which links to a navigation index page for each of the images in the exhibition. I used small images on this page as navigation buttons. Clicking on any of the small image buttons will bring you to an enlarged version of that image. From the enlarged images, you go back to the navigation page. The navigation page also links to the quotes index page. On the quotes page are small house images. These

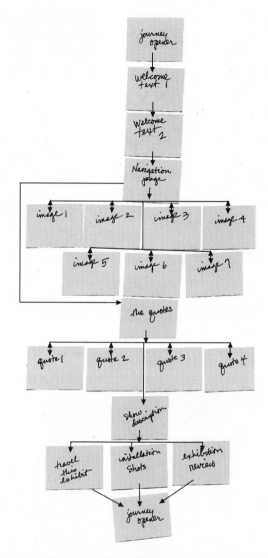

Site plan/map for exhibition the journey.

...re buttons for the quote pages that change from plain to glowing when ...ou roll over them with your mouse. Clicking on them will bring you to ...a page with the full quote. From the quotes, you go back to the main ...quote index page. Also on the quotes page is a link to the show descrip-...ion page. From the show description page there are links to a page ...about traveling the exhibit, installation shots of the exhibit, and a link ...o an exhibition review. All these pages link back to the opener.

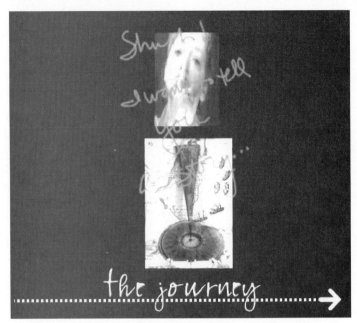

Pages for exhibition website for the journey *at* www.nku.edu/~houghton/journey/journey1.html.

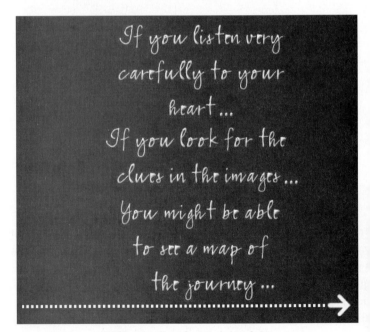

Welcome page to the journey *website.*

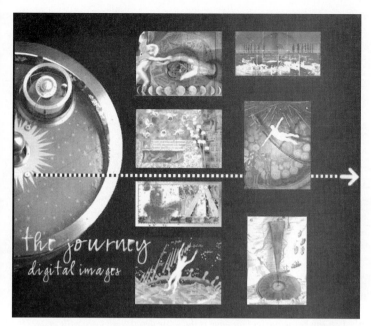

Digital image gallery page links to an enlarged image of each piece.

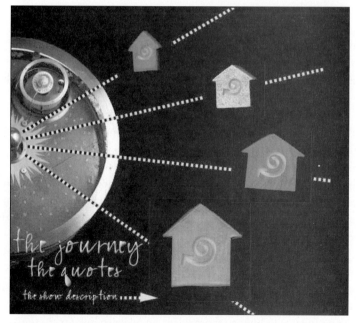

House navigation page links to quotes used in the exhibit on the sheer panels in front of the still-life settings.

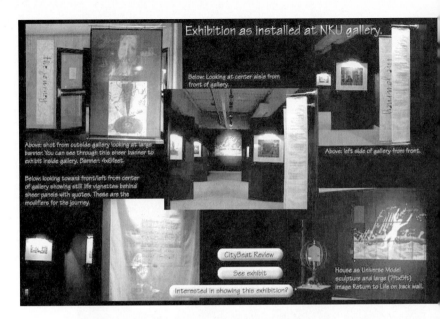

Linked off the house navigation page is the show description page with images from the installation.

Because the exhibition was in a very darkened space with controlled lighting, I made the site on black background pages and kept it rather spare. I used the same typeface as I did in the exhibition for the website text font. I tried to help my visitors understand what it was like to stand in this exhibition space.

I want to make a note at this point about putting your artwork as an exhibit on the Web. Your images can be downloaded by anyone visiting your pages. However, the quality of images when downloaded from the Web is very poor, so the chance of someone "stealing" your work for profit is slim. Images will look better when viewed on the Web than when printed out from web pages, because images on the Web are generally no better than about 72 dpi and that rarely gives very good detail when printed out.

SITE MAPS AS PAGES OR AN INDEX

Some people put site map pages in their sites for those who need help navigating or to streamline the search for information on a site. The site map page is merely a contents page with all of your pages listed in outline text form with links to those pages. In order to link text to the

specific pages on your site, you would use a web program. Once in that web program, you select that page's name in your outline list and then add the URL for the address of the page to the place on your web program where you write in the link information.

http://w3.one.net/%7Ekayla/siteindex.html

```
...SITE.INDEX...

art sites>                              the spiral>
    sketchbook                              the Spiral of Insanity
        prints                                  (see above for some links)
        pen, brush, & ink                       the looney bin
        links                                   mu* listing
        black & white photo                     quotes & quips
            1 self portrait & russ
            dad, brittani, & bianca     jade MUX>
            waffle house hijinx             welcome
        digital photo                         concept
        goddess inspired art                  jade library>
            cotg & more art                       news files
        artist bio                                    history
    ye olde sketchbook                                role playing tips
                                                      vampire file
characters>                                           lycanthrope file
    characters & mu links                             character creation
        nightscape MUX>                       city files
            arden archer                      cast of characters
            amber daya                        log files
            angel raphael                     glossary of terms
            victoria blake                    F.A.Q.
                                          jade BBS
writing>                                  staff
    poetry                                jade links>
        12                                    mu* resources
        illumination                          player pages
        the jeweler
        74
        surviving teenagers
```

Nicci Mechler's site index at http://w3.one.net/~kayla/siteindex.html.

This is very helpful on large informational sites, but not really necessary for smaller personal sites. That way, people have more than one way of navigating and more than one way of finding the information they are looking for. If you look at the website for Apple Computer, you will see that there is a tab navigational double bar at the top with general areas within their site. If you go to **Support** and then to the **Support Index,** you will see what a very large site map or site index looks like. Each underlined entry is a link to another whole set of pages or areas. Your personal site won't need this, but someday you might make a site for someone who does.

PAGE SIZE CONSIDERATIONS

As you begin to design your site, you should consider what size your pages will be. Most people have small monitors, so if you set your canvas or page size to 640 × 460, your whole page will show on most monitors. If you design with your own large screen in mind, most of the rest of the world will have to scroll around to see your designs. So, my advice is to make your pages fit the smaller monitors so that more of your visitors will enjoy your site as you wish them to do.

If you want your viewer to be able to print out one of your web pages on a single sheet of paper, then make sure that you design this into the page size or make a link on that page to a printer-friendly version of the information. That page will be made with simple fonts and no graphics usually. You have the choice of the landscape or portrait formats. Test out your ideas to see which works best in print, but remember that web pages rarely look as good in print as on your monitor.

WEB BROWSER SAFE COLORS

There are 216 web browser safe colors, each with a specific designator or hex decimal number. These are the colors that are sure to show up accurately on your web page when it appears on your visitor's computer. Most web development and design programs have the color chart built into them, as do Photoshop and ImageReady. When you use ImageReady to save your images for the Web as a .gif file, it will automatically translate the image to use safe colors. In Photoshop you can determine if a color is web safe by using the web safe ramp option in the color menu. Most of the time, you will not have to worry about this if you are using a web program because that program will make the web safe palette for you and force your images into it.

Web safe colors from Photoshop/ImageReady.

Web safe ramp menu from Photoshop/ImageReady.

TEMPLATE PAGES

Once you have decided on a page size, then you can create a template page or two to begin working on your site. If you want all or a group of your pages to have certain elements on them, such as navigational bars with buttons, a specific background picture, a specific color background, or a logo, then you should create a template page. When you begin to make the separate pages from the templates, remember to save each with the new page name. You can then add all the information to groups of pages without ruining your template page.

LINKS

When designing your site, it is important to consider what you will link and what you won't. Not every word or image needs to be linked to another page or place on a page—you should link important things. Some web programs will let you create image maps where parts of an image are hot and when clicked upon will take you to another place. All programs will let you link words as well as buttons. You should follow the specific directions that come with your web program to learn how to do this.

You can make links of buttons, words, pictures or icons, and areas of an image as imagemaps. Make sure when you decide on a link that

there is a visual clue that the link is there. Then consider how you want your visitor to move around your site. If you give the visitor two ways off a page, will that person ever return to the path not taken? How can you direct the visitor to the entire site without boring him or her? One of the most frustrating things is to have too many links that take visitors off into space and make them forget what they were looking for to begin with. Make sure you make the navigational links easy to understand and that these jump-off places load quickly and easily so that your visitor will not get tired of waiting for the page to load and reload and leave your site unseen.

FRAMES

Navigation with frames on a page is a common device used in many web pages. In a page that uses frames, one part of the page will change with new information when certain buttons are clicked, leaving the rest of the page the unchanged. Usually the buttons are in the frame that doesn't move. Not all browsers work well with frames, although most will.

Frames can be very handy but, if not designed well, are often so small that the information in the frame is indecipherable. Use frames only when necessary. Carefully study sites that use frames and deter-

Frames example.

mine what you like and do not respond well to before you undertake using them on your own site. Use them when they make sense, and don't use them when they are just a flashy device.

At first glance frames might be confused with tables. However, frames usually have sliders on one or more sides. However, judging this can be tricky. Some frames are designed to hide the borders and have no sliders. If you click on a button that may be along one edge of the window or page and only another part of the page changes, this will tell you there are frames on this page. On frames pages, there can be more than one frame on a page. Usually, good designers put the navigational bar along one of the borders on the left or right side, and there is a banner of some sort at the top of the page. The actual page content is on the changing window or frame in the center.

Many web design programs will have some templates that show a variety of ways you can divide your browser window for your web page. If you decide to go this route, carefully decide what would work best for you and your site. Be careful not to make your page look like a slot machine with many vertical scrolling columns. Remember that you are trying to communicate information with your web pages and too many scrolling elements will just confuse your visitor.

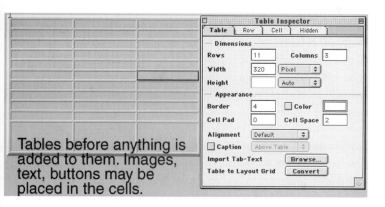

Tables in GoLive! From Adobe.

Pages That Scroll

Your pages can scroll vertically or horizontally, depending on the size of the page or canvas. Never have your page scroll in two directions. Vertical scrolling usually works better because reading the down the page is our more normal way of doing things. Horizontal scrolling can be interesting if done tastefully.

When scrolling must take place in two directions, the visitor has more to do than pay attention to what you have to offer on your page. He or she has to keep track of the scrolling bar and what you are saying. It just isn't great practice to make users do all that work. Think about how you can make your pages attractive and still have them fit on a small monitor.

CONSISTENCY IN YOUR DESIGN

When you design your pages, rely on repetition of specific elements to give your visitor a clear sense of how the site is set up and how it works. Repeating certain elements such as navigational buttons, roll-overs, or page layout will give your site a consistency that will make it appear more professional than if the page style changes with every link. For example, your repetition might be in the use of a set of colors that appear on all the pages. Those colors might be used to set the tone for the entire site with some at full opacity strength and some more transparent. You can be creative on how you integrate the color scheme that you decide to use for your website.

Color

The use of color is a matter of style; artists are well known for making bold uses of color in their work and often break rules on how and where color should be used. I am not going to give you rules, except to tell you that websites hold together better if there is some consideration on how the color is used and reused in a site. Since we are interested in having our websites communicate to others, it seems as if we might want to use whatever devices we can to help that along.

Page Size

Another thing that might help your website to look professional is to be consistent with the horizontal size of the page or canvas or window. The reason is that when someone opens the first page of your website, he or she might use the window sliders to set the browser to fit the first page. If you are not consistent in the size from page to page, a good portion of your well-conceived design might be off the screen when your visitor gets to the important page. Making the decision on the page size early in the design will help you keep that professional look. People are more apt to scroll down on a page to see more information than they are to scroll to the right.

Further limiting the use of typestyle and typeface helps reinforce the professional look of the site. When you mix and match typestyles and typefaces showing how many you can use, you also will tend to show that you are an amateur and you may stand the chance of not being taken seriously. I find it hard to look at type that has been resized to change the type's style. Some software packages allow you to change the type size and style by dragging the bounding box to transform the type width or height. This can make the type look very peculiar and less legible to read. Clean type is usually preferable.

Type on a web page
Type on a web page squished
Type on a web page stretched

Type squished.

As you can see, the type that is squished is harder to read, and the type that is stretched looks like bold type when in reality it is normal. It is almost impossible to get all the altered type to be the same on a page so it will look like you couldn't make up your mind when designing the page.

Another consideration about the design of the type on your web pages is whether viewers will be able to see the typeface you use if they don't have it on their own computers. Unless you use a program that allows for the page to be translated to a graphical version of it, this may be a problem for you. ImageStyler and LiveMotion are sure to keep the type exactly as you designed it, because all the elements on the page are exported as images into the HTML file. This means visitors will see your page as you designed it and not only as their browsers translated it.

If you use a set of navigational devices that are placed in the same place from page to page, the site will hold together quite well and allow the visitor to look at what is presented rather than have to try to find out where to go. In the following example, Keri Yates uses an artist's palette as the navigational device on her gallery pages. She sets the stage for the viewer on the main gallery page with the names of the groups of work on the palette and then inside with small paint smudges of each of the works in the same places.

NAVIGATIONAL ELEMENTS

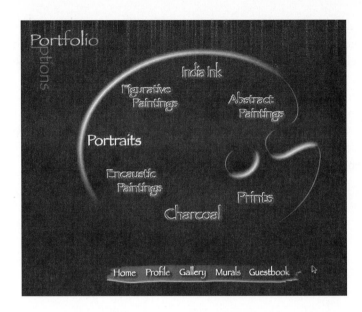

This is the opening gallery page.

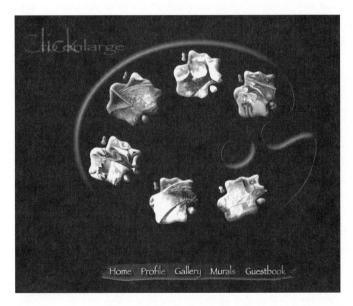

This is the Abstract Paintings page.

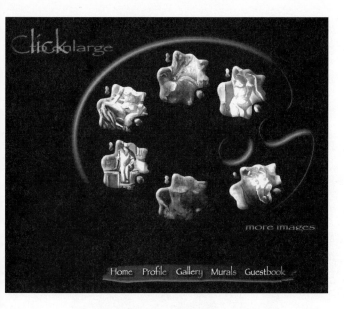

This is the Figurative Paintings page.

What she so nicely does is set it up for you to already anticipate the images by using this delightful device of the artist's palette and how the paint looks on it. Rather than the normal gallery page, Keri took one more step in showing more about herself as an artist. When you click upon the various palette smudges, you will open up the enlarged artwork on a page with information about it. That new page with the enlarged artwork has a small smudge button to take you back to the palette. Keri used very ingenious navigational devices but set them up so that the viewer could understand the system quickly.

In another website for Douglas Prince's retrospective exhibition, the device used to indicate which images could be seen enlarged is a small box in the corner of a normally setup gallery page. The box is the same color as the navigational bar at the bottom of the page. Careful consideration was given to a set of colors used on this website to reflect the university colors and also to keep the site elegant with all the information that was included.

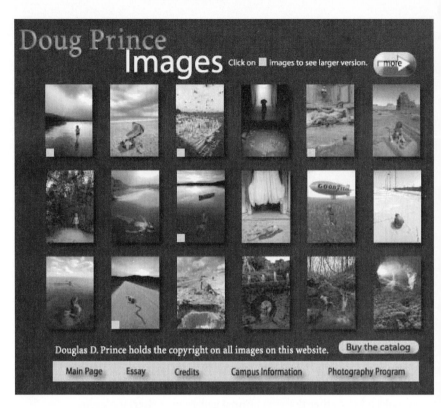

Doug Prince: http://www.nku.edu/~photo/prince/.

WEBSITE COLOR SCHEME

When building your website, it is a good idea to preselect a set of colors that you will use consistently throughout your website. The color set will add to the professional look of the site and give your visitor a sense of order in how your site is arranged. You can decide to make an arrangement for each level of the site. For main pages, there may be a specific template with specific colors assigned to buttons, navigational bars, and headlines. Then, on the next level down, all pages may use the same colors but in a different arrangement. Maybe there the header would be the color of the button that led you to the page, the navigational bar might be the color of the previous level's header, and so on. Introducing many more color sets into one website can only add to the confusion of your visitor unless the website is so clearly considered for navigation.

design

glasgow school of art

welcome

general information

departments

silversmithing and jewellery

this site is optimized for : netscape 3.0+ | ie 4.0+
(the navigation will not work as designed when viewed with earlier versions of these browsers)

designed and built by andrew massey | © january 1997

Glasgow School of Art/School of Design color scheme.

On the website for the Glasgow School of Art in Scotland, a very clever color scheme was considered for the School of Design. When you go into the School of Design's site, there is a color rainbow in the squares in the middle of the page. When you roll over each of the squares, one of the department names appears. Then when you click down on the mouse to go to the chosen department, the same color will be flashed as the opening page for the department is loaded. The color scheme will appear with that color as dominant for that department's scheme. On the department page, the color in the top right corner is the color assigned from the School of Design page. All the buttons are outlined in the same color throughout the site. This clever use of color reinforces the sense of order to a very dense site.

			silversmithing and jewellery	
			school of design	
			glasgow school of art	

What are *you* looking for in a silversmithing and jewellery department?

Glasgow School of Art/Silversmithing and Jewellery department.

Assignment: Now that you have been introduced to what you will need to make a site map, spend some time with self-stick notes making a slip for each page you want to have in your website. Paste the slips in the order you envision on a larger sheet of paper or board. Draw arrows to indicate which pages will link.

Show your site map to someone else and see if he or she understands the flow. If that person has any concerns about your site, carefully listen to these concerns and see how you can improve your first site map. Use this site map to create your website as you move on in this book.

URLs Used in This Chapter

- the journey: *www.nku.edu/~houghton/journey/journey1.html*
- Nicci Mechler: *http://w3.one.net/~kayla/siteindex.html*
- Keri Yates: *http://www.nku.edu/~yatesk*
- Doug Prince: *http://www.nku.edu/~photo/prince/*
- Glasgow School of Art: *http://www.gsa.ac.uk/*

4

OVERVIEW
OF
PROGRAMS USED
FOR
WEBSITE CREATION

Scott French's animated opening page for his website done in LiveMotion.
http://www.nku.edu/~frenchc.

This chapter will discuss some of the many programs that can be used to create websites. Overviews of Adobe products Photoshop, ImageReady, PageMill, LiveMotion, GoLive, and Acrobat will be given. Also included in the overviews of web creation programs are Home Page, Macromedia's Dreamweaver/Fireworks Studio, and Flash. The overviews will help you make informed choices for purchasing and learning some of the software available for web creation. Major attributes of each program will be discussed, as well as programs designed to assist you in placing your web pages on your server. These programs are called File Transfer Protocol programs, or more commonly, FTP programs.

BASIC PROGRAMS

ADOBE PHOTOSHOP

One of the best known and most commonly used programs for image editing/creation for web or print media is Adobe's Photoshop. This program has been around for many years, and it is the industry stan-

Photoshop showing variety of windows, toolbox, and image.

dard for image editing. Photoshop is not a drawing program, although you can use it to create images by drawing. It is powerful and very complex, although its user interface is intuitive and quickly usable for even the beginner. One cannot expect to know everything about Photoshop due to its complexity and the fact that most users do not use all the features built into this powerful program. Most find a set of tools within Photoshop and use those. Other users will find a completely different set of tools necessary for the work they do within this program. When first developed, Photoshop was geared most closely to working with photographs or scanned images to correct image errors, blend images together, or correct color balance. Artists and designers found exciting uses for the program and suggested changes that would make it even more powerful. In the latest versions of Photoshop, the people at Adobe added features that included web enhancements and another Adobe product within Photoshop to make the job of web design and creation much easier. The ImageReady portion of Photoshop will allow the user to import images scanned into Photoshop and then optimize them for use in websites within seconds. An excellent preview feature allows the user to immediately see which version of the image will best suit their site. The user can compare quality of image and download rates at a variety of modem and cable speeds to help make the decision of which one to save. Then it is only a matter of saving that version and bringing it to the web development program.

ImageReady also allows you to create buttons, roll-overs, and sliced images for use in your other web development programs. ImageReady is fully integrated with Photoshop so that its use is seamless and efficient.

ADOBE PAGEMILL, A BASIC WEB PROGRAM

PageMill is a basic page authoring program that allows you to enter text and place images without writing HTML code. With it, you can drag and drop images and links directly onto a web page. You can build and preview images, text, animations, sounds, tables, and links on your web page. You can also manage your website and upload it to your host server with this program. Although it does not offer any fancy enhancements like floating windows or overlays, it is a solid and respectable program for making websites.

When you open PageMill, the window will look like this:

*PageMill window in the **Edit** mode.*

You will be able to select the style of headline and formatting. You will also be able to select the font from your system that you wish to use on your pages. The tool and formatting bars give you a variety of other selections, allowing you to choose how you want your text aligned and insert a graphic image, table, horizontal bar, as well as form selections of checkboxes, radio buttons, text boxes, pop-up selections, and submit and clear buttons. PageMill will allow you to make an image into an image map where parts of the image are really invisible buttons that will link you to other pages or places on the page.

With PageMill, you can build your page in the edit mode, then, by clicking the box at the top right, move into the preview mode to see how the page will look on the Web.

PageMill window showing what the tools are used for.

You will also be able to look at the statistics for the page to see the download times. If you wish to see the HTML code to insert or change

the code, you can do that by selecting **View Source** in the **View** menu. PageMill is not a fancy program, but it is a powerful one. With PageMill you can also manage the entire website and check on all the links to see that they go to where they are supposed to go.

A handy program from FileMaker is Home Page. Like PageMill, it is a basic program that allows you to create and manage your website. Its simple and clear design gives it a fast learning curve. With this program, as with PageMill, you will be able to write your text directly onto the page and also import graphic images. In order to control your page layout, you must either set up tables that will allow for some control over the placement of graphics and other elements or let the program slide everything as it would text to line up with the right or left margin, centered or indented slightly. With this program you can use a variety of your own fonts and select the color for the text. You can check your links and manage the site. You cannot, however, create buttons, shadows, or any other effects within this program. You could not do this in PageMill, either. Here are the menus from Home Page. You will find that they are very similar in function to those in PageMill.

File ▶	
New Page	⌘N
New...	⇧⌘N
Open...	⌘O
Open Folder As Site...	⇧⌘O
Close	⌘W
Close All	⌥⌘W
Save	⌘S
Save As...	⇧⌘S
Revert	⇧⌘Z
Library	▶
Remote	▶
Page Setup...	
Print...	⌘P
Quit	⌘Q

HP **File** *menu.*

*HP **Edit** menu.*

*HP **Insert** menu.*

*HP **Format** menu.*

*HP **Style** menu.*

*HP **Window** menu.*

*HP **Help** menu.*

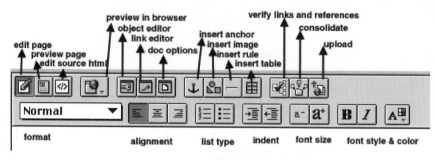

HP Toolbar.

Packaged with Home Page is a relatively extensive clip art file that is usable in making your web pages if you are in need of line drawings for buttons or illustrations.

ADOBE LIVEMOTION

A new addition to the lineup at Adobe is LiveMotion, which was first introduced in 2000 to replace ImageStyler. LiveMotion is a more powerful program that allows for the introduction of scalable vector graphics, Flash animations, and HTML coding.

Unlike most other web programs, LiveMotion allows the user to create content directly within the application rather than import all the elements from other programs. This direct approach is not only quite convenient, but also helps you focus more on the creative possibilities because you can see immediately what you have done, leaving more latitude for incremental adjustments or changes. LiveMotion is an intuitive and interesting hybrid program. It is direct and very friendly to use. Working much like Photoshop, it allows the user to make a page that is 100 percent editable and then export that page with all of its effects, roll-overs, and links directly to an HTML document to upload to the Web. The exported HTML page is not editable by anyone without the original LiveMotion (.liv) file. LiveMotion lets you do such sophisticated functions as place an image in the window, then apply a gradient to it as you might in Photoshop, while having part of the image translucent. You can work in layers with overlaps and varying degrees of opacity. Words can overlay pictures and be buttons at the same time. You can make a small rectangle on the page and then select the **Replace** command and your image will be resized to fit within that box without going back into Photoshop to resize the image. This allows you to make a larger jpeg image and use it for both the button and the image.

This program is a lifesaver for many web-savvy creators. Even with its present limitations of not being able to import some multimedia elements like QuickTime movies, artists can create wonderful pages in minutes without having to know any code. The pages placed up on the Web are stunning. A shortfall of the program is its inability to handle long text areas. If you are typing a long paragraph, LiveMotion will slow down as you continue to add the words to your text. To accommodate this problem, you will have to make multiple text boxes. You can align objects and boxes and distribute them evenly across the page either horizontally or vertically.

Many web professionals use LiveMotion to create content for insertion into other web programs such as GoLive. However, if they really thought about it, there is very little reason to do that when LiveMotion can do about all that other more complicated programs do. For students and faculty interested in the finer points of web creation, this is a program that suits them. Most people can sit down at the computer with LiveMotion and learn enough to make pages in less than 10 minutes. No other program I know about or tried has this easy a learning curve.

In LiveMotion the user can:

- Create buttons and effects for buttons such as roll-overs and remote roll-overs.
- Create Flash® animations.
- Type text, and give it a variety of effects and attributes.
- Overlay any object either brought into the program or created within it.
- Save buttons or objects with all of the style attributes and roll-over effects to reuse at any time.
- Create complex websites fast because there is no steep learning curve such as those encounted with many other web programs.
- Create HTML pages generated from the LiveMotion saved pages. The LiveMotion pages can be edited at any time and altered in any way and then can regenerate new HTML to upload onto your website.
- Adjust the opacity, softness, saturation, and color of any object or element.
- Transform any object or element in size, weight, or distortion.
- Create color schemes so that the use of consistent color can be used throughout the website (most programs force you to go back to the

previous page and select the color with the eyedropper and then bring that color to the next page).

- Add HTML code into pages easily.

MORE ADVANCED WEBSITE DEVELOPMENT PROGRAMS

ADOBE GOLIVE

Adobe's GoLive is a complex web development and design program geared for the web professional who wants complete control over the page design, yet still wants to be able to add HTML and JavaScript code into the pages in a direct way. The creation of buttons, effects, and most styles need to take place outside of GoLive, although some styles are available from within the program. The nice thing about this program is its ability to let the users place everything where they want on a page by way of floating palettes and windows. With GoLive, you can control just about everything you can imagine. With this program you can import graphics, multimedia movies, and sound. You can control the opacity of a window or a floating graphic.

Opening up the GoLive program window will show you not only that window but the palettes available for use when building your web page.

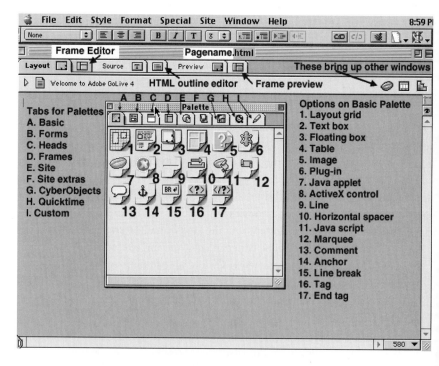

GoLive opening page with palette.

GoLive allows you to drag out a layout grid on which to place your objects for precise layout control.

With GoLive, you can drag a layout grid onto your page that will allow you to place all the other pieces on the page in a precision layout with complete control over the look of your page. All the objects are drag and drop, so you simply drag an image palette out onto the page. It will then hold the place for you to browse and get the image to fill it. You can resize any of the objects you drag out onto the page and apply a number of options to them. Each can be linked as a button to other pages or places. You can even enter the keywords that help the search engines find your page in a little box just under the title of the page in the Header box. By dragging icons from the Head Palette, you will add content to the Header portion of the HTML script that will be visible from the Source view.

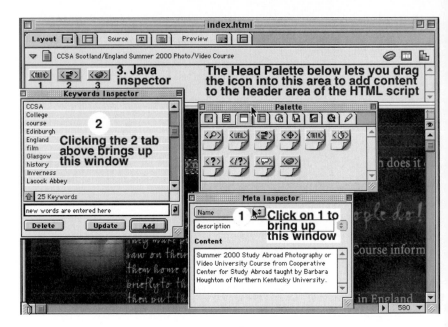

GoLive palettes.

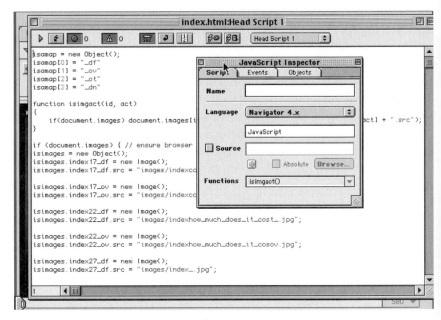

GoLive Source Code and JavaScript Inspector.

CHAPTER FOUR

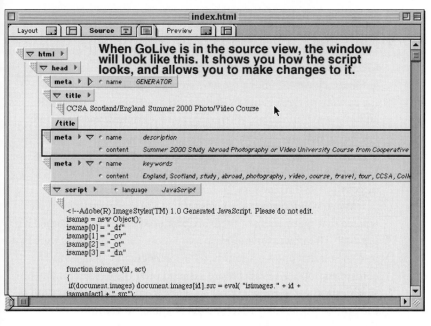

Looking at the Source Code in outline form in GoLive.

When in this Header box, you can also check and add to the JavaScript by clicking on the Java Inspector. Looking at the Source window will let you see how the page is constructed; if you are familiar with writing HTML, you will be able to check your work and make changes where necessary.

While not as direct as LiveMotion, where you create most of the parts within the program itself, this program is one in which you will create most of the parts outside of GoLive and then import them into the program through a series of dialog boxes. These dialog boxes allow you to browse to find the element and then select it for the pages. You can manage the entire website and check all the links from windows within the program. You can create styles and save them. You can also view and add to the HTML coding and finesse the JavaScripting.

From within GoLive you can make objects move or show up on a timeline to animate your site or page. There are a myriad of controls in GoLive that will help you to build a truly interactive website. However, this program has a pretty steep learning curve and is not as intuitive as LiveMotion was, so plan on spending some time learning the complexities of this program before you take on an entire website project with it.

Macromedia Dreamweaver/Fireworks Studio and Flash

Macromedia has produced a comprehensive suite of software programs for website creation: Dreamweaver/Fireworks Studio. That Studio, along with Macromedia Flash, will allow the web designer to create websites with dynamic animations and sophisticated graphics. However, unlike the newer programs offered by Adobe, the content of the website must be created outside these programs and imported into them, where very concise controls can be found. For many web creators, this poses no problem or issues, but for others, working in Adobe products seems easier because of the less-steep learning curve and the convenience of being able to do things directly.

When you look at many websites that are available online, you will see that many more of them are produced with the Macromedia products Dreamweaver and Flash animation. These products were first into the market and set a standard for many graphic designers. The control and options available are vast and offer the designer many possibilities without having to write the code from scratch. Integration of the products offered by Macromedia is similar to the integration of those offered by Adobe. However, most artists and designers will use Adobe's Photoshop for image creation and editing as well as the effects. Macromedia's Fireworks mimics some of the filter and effect controls offered by Photoshop; however, when it comes to text control, Fireworks then mimics Adobe Illustrator. What you are used to using normally before you were doing web design will most likely influence what products you choose to use. Each of the products has excellent capabilities.

DREAMWEAVER

Similar to Adobe's GoLive in its approach to web creation, Dreamweaver is a program that gives you complete control over the placement of objects and elements on the web page. It is a visual editor for website layout and design. Built into its capabilities is the ability to generate the HTML coding necessary for reading on the Web. Its underlying structure is based on an endless variation of tables that allow for placement of the elements on the "page" in layers with transparency and with the addition of animated elements such as roll-overs, simple animations, and Flash movies. With Dreamweaver, there is a steep learning curve due to the complex nature of this program.

Dreamweaver opening window with palettes for controls.

As you can see from the illustration, Dreamweaver has many functions and abilities. It is not an intuitive program. It is a very powerful one, however. Within Dreamweaver, you can even create timeline animations with the layers that you create within the program. Shown in the illustration is the Launcher, which is used to open and close various palettes, windows, and inspectors. A Mini-Launcher is also available at the bottom of every document window. The palettes in Dreamweaver are floating and dockable, which means that they can move around your window and the tab selections can be shuffled and reattached to other most-used palettes. The Property Inspector is used to examine and edit properties of currently selected page elements or objects. The changes made with the Property Inspector will show up in the document window right away.

The Objects palette allows you to insert objects into the document window. Looking at the Objects palette will show that you can drag these elements into the window to add such objects as tables, images, layers, links, and elements created outside of Dreamweaver, such as Flash movies, Shockwave elements, and others.

Dreamweaver Objects palette.

Other menus are available with the Objects palette such as the **Character, Frames, Forms, Head,** and **Invisibles** menus. Each of these menus has a variety of selections to add more control to your web design. The **Common** menu panel contains the most-used objects. These are **Image, Table,** and **Layer.** The **Forms** menu panel contains buttons for making forms in a variety of styles; it also contains form elements. The **Frames** menu panel contains common frameset structures. The **Head** menu panel contains buttons for the addition of a variety of head elements such as META TAGS, KEYWORDS, and BASE tags. The **Invisibles** menu panel is for creating objects not seen in the Document window, such as anchors and comments.

Many contextual menus also provide the most commonly used commands and properties for each of current selections.

FIREWORKS

You can use Fireworks in tandem with Dreamweaver to create web graphics and to optimize already created images. Fireworks is an image editing program for use with other web creation programs. With it you

can also create roll-over effects for buttons and edit vector and bitmap graphics. You can also apply styles to objects. Images created in Fireworks can be used in other graphics programs and can be printed as well. It is similar in some respects to Photoshop 5.5 with ImageReady. Although not as powerful as Photoshop, it has many features that are very useful for the creation of web graphics.

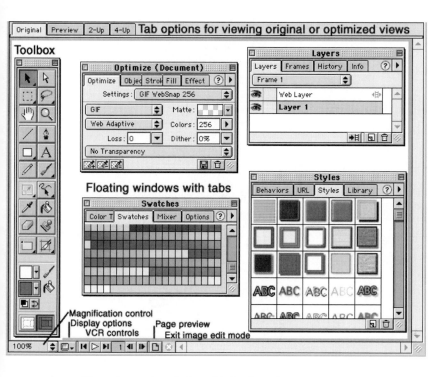

Fireworks opening window with floating palettes.

An opened new window in Fireworks will allow you to open a variety of windows that are floating and dockable. You will see that there is a toolbox with tools that look familiar if you know Photoshop. Similar to ImageReady are the Tab options at the top of the window that let you preview images in the variety of optimized levels. Each of the tab options available in Fireworks gives a host of opportunities for control of the graphic image. You can also create simple animations in Fireworks and play them back using the VCR-like controls at the bottom of the document window.

Similar to Photoshop are the Layer, History, Info, and Color Swatch windows. Similar to Illustrator or Freehand is the ability to work in sophisticated text controls including allowing the text to attach and flow following a path created with the pen tool.

*Fireworks **Text** menu.*

Fireworks' text flow ability is similar to Illustrator.

With this text flow ability, you can create rotated around a path, skewed, and vertically aligned type. And if your type exceeds the length of your path, the type returns and will repeat the shape of the path again.

You can also apply Xtras that can include your Photoshop filters. These effects can be applied in Fireworks to enhance the look of your

images. Also, as in Photoshop, the **Adjust** menu under Xtras contains many of the same functions, such as Levels, Curves, Brightness, and Contrast. These controls allow for fine-tuning adjustments and the application of special effects to your image.

Fireworks Xtras menu and submenus.

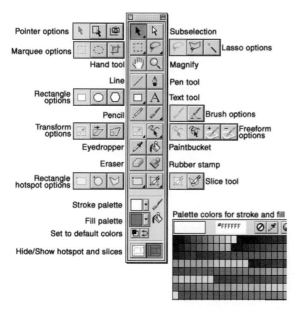

Fireworks toolbox.

The Fireworks toolbox has familiar tools and will give you many of the other options you will need to complete your artwork for the Web. It will also give you the ability to create hotspots on your compositions and slice them for export to the web program of your choice. Once again, I want to tell you that this program is designed to work with Dreamweaver.

FLASH

Macromedia's Flash allows you to create vector graphic interactive movies for websites as well as animate bitmapped graphics. Flash is used to create animated logos, animated short movies placed in websites with synchronized sound, and animated interactive navigational controls. These Flash animations are very compact and therefore download quickly and scale to the viewer's screen. In Flash you can create movies by drawing or importing artwork from other graphics programs like Photoshop, Illustrator, Fireworks, and Freehand. Placing them on the working composition window called the Stage will animate them.

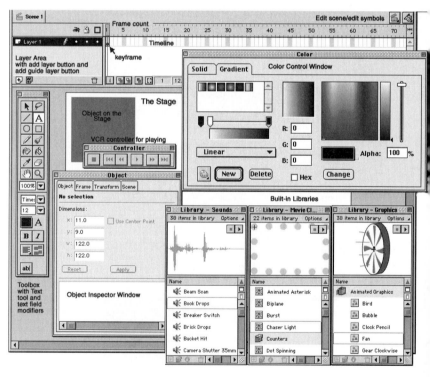

Flash opening window with Libraries, Palettes, Controllers, Timeline, and Menus.

CHAPTER FOUR

Opening Flash will present the Stage—the window where you create your movie. Flash is a complex and powerful program with a rather steep learning curve. However, its power may compensate for the time taken to learn the program. The Stage is where you compose individual frames in the movie by drawing directly upon it with the vector graphic tools or arranging imported artwork. The Timeline window is where you coordinate the animation and assemble the parts of the movie, consisting of the artwork on separate layers. Think of the Timeline with the layers like old-time animations where each layer was a separate transparency with drawing on it. As the transparencies change or are edited, the animation begins to move.

Adobe Acrobat can add PDF (Portable Document Files) to your website for easy downloading of information or documents. Acrobat can be used with any of your existing word-processing or layout and design programs as well as with your image programs to create flyers, technical documents, and resumes that can be downloaded and printed up by the visitor while still retaining your formating and style. Normally, if a visitor does not have a specific program and version of that program on his or her computer, documents created in, say, Quark, cannot be opened by that computer unless it has the same version of a program. With Acrobat, that document is translated into a PDF file that is readable with any free Acrobat Reader. The Acrobat Reader is free and can be downloaded from the Adobe website at *http://www.adobe.com/.* Installing this reader and its plug-in on your computer and in your web browser plug-ins will allow you to read the PDF documents while browsing and also while using your computer for other purposes.

Adobe Acrobat PDFWriter Page Setup window.

Acrobat is very easy to use. Creating documents in the PDF format is as simple as selecting the document you wish to translate and dragging it over the PDFWriter icon on your desktop. That will open your original creation program, and then you simply select the options you wish and tell it to go ahead and create the PDF. You can also select the PDFWriter in your Chooser and simply select **Print** and it will print the document to a PDF file rather than to your printer. Later these files are uploaded with your HTML files to your server.

Assignment: Go to the websites for Adobe, Macromedia, and Filemaker and read the information found there about each of the programs that you want to try out. Download the trial versions of programs and install them on your computer or ask if you can install them in your lab to try out. Make notes about what you like and dislike about the ones you try.

Websites for These Downloads

- Adobe: *http://www.adobe.com* There is a link off the main page for free tryouts and demos. Programs made by Adobe are PageMill LiveMotion, GoLive, Acrobat, Photoshop with ImageReady.
- Macromedia: *http://www.macromedia.com* There is a link off the main page for downloads. There you can find trial software. Programs made by Macromedia are Dreamweaver, Flash, Fireworks.
- FileMaker: *http://www.filemaker.com/products/try_filemaker.html* This page has HomePage 3.0 trial version at the bottom.

PROGRAMS USED TO UPLOAD YOUR PAGES TO THE SERVER

FETCH FOR THE MACINTOSH

Fetch is a file transfer protocol program that allows you to easily connect to your host server and manage your files and web pages while online. Fetch allows you to save your connection as a shortcut to quickly connect and ready yourself for uploading the necessary files. With Fetch you can drag and drop files into the Fetch window, which will automatically place the pages within that folder on your server. It will let you create new directories or folders on the server and dispose of unwanted files by allowing you to delete them by dragging them to the trash.

Some of the simple web creation programs allow you to upload files for your website. Fetch is so clearly simple and easy to manage that it has become a standard FTP program for many web developers.

If you are a student, or an employee of an educational institution, or a member of a nonprofit institution, Fetch may be downloaded for free from *http://www.dartmouth.edu/pages/softdev/fetch.html#News*.

Like Fetch for the Macintosh, FTP Voyager is an FTP program that allows you to easily connect to your host server and manage your files and web pages while on line. You are able to drag and drop your files into the window that will set off the uploading to your server and create directories or folders on your server and place files in those folders or directories. You will also be able to delete unwanted files easily.

FTP Voyager
for Windows

URLs Used in This Chapter

- Adobe: *http://www.adobe.com/*
- Macromedia: *http://www.macromedia.com*
- FileMaker: *http://www.filemaker.com/products/try_filemaker.html*
 Fetch: *http://www.dartmouth.edu/pages/softdev/fetch.html#News*

5

PRACTICAL GUIDES
TO
MAKING WEB PAGES:
Creating and Integrating Image and Idea on Web Pages

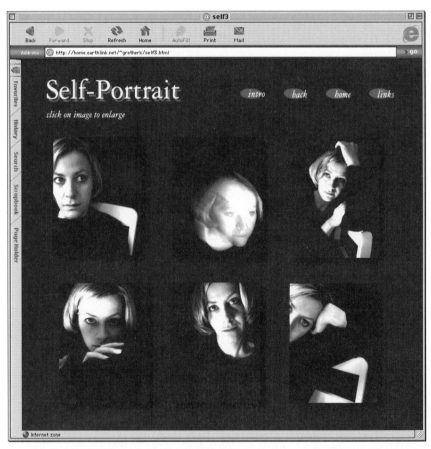

Kelly Grether's Self-Portrait page from her photography website at http://home.earthlink.net/~gretherk.

THIS CHAPTER WILL give you practical information on creating your web pages by discussing the issues about design, navigational ideas, and images that you will need to decide. You will be given short tutorials using Photoshop, ImageReady, PageMill, LiveMotion, and GoLive. You will learn how to animate your pages with LiveMotion and create some advanced roll-over effects. At the end of the chapter are two assignments using the same software covered in the tutorials.

Some things to remember when you begin making your pages and images for the Web:

- Use only lowercase letters in the names. Some servers are case sensitive so it is easier to use only lowercase.
- Don't put any spaces or punctuation in the names of pages or graphics. This means no periods, except in the .html or .jpg suffix, no / or \, no colons, semicolons, apostrophes, or any commas.
- Keep a list of each page and graphic for reference.
- Give all your links exactly the same name as you name the page or graphic.
- Remember that you must have the .html, .jpg, .swf, .gif, etc., suffix behind the name of each page you link or graphic you link.
- Remember to give your visitor options to return to main index pages or to the home page.
- Decide if you want to let your visitor contact you by email from your web pages.

Making your website interesting and reflective of your tastes, your artwork, and your ideas is the key to making it successful. You have collected your images, have them web ready, and have your flowchart. Now it is time to begin to assemble the site, piece by piece.

When you picture how you want your website to look, have you clearly seen the overall look in your mind's eye? If so, how does what you have in your mind translate into reality?

Your first website should be streamlined so that you can create it without having to learn such things as animation, video, complex software, or scripting. Make your first site clean, easy to use, and direct. There is nothing worse than going to a site and having everything fly around, spin, and make noise, so that you are visually overloaded. Keep it simple and later you can add in a few frills where they are necessary.

If your site is about an exhibition, do you want the viewer to get a sense of what this work would look like on gallery walls? If so, how can

you accomplish this exhibition look? One way would be to do a simulated overview showing the work as if it were placed on the gallery walls. To do this, you might want to use Photoshop to import the various pictures, then, by using the Perspective tool in the Transform menu, size and shape the pieces so that they appear to be hung on the walls.

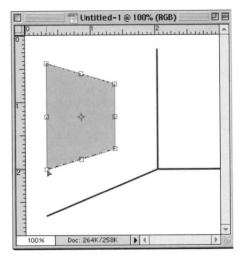

Photoshop using perspective tool to create gallery.

You might use the Filter > Render > Lighting Effects to light the gallery walls.

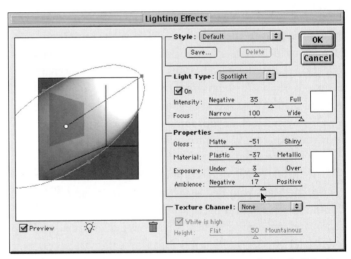

Photoshop Lighting Effects Filter window allows you to design the light in your virtual gallery.

CHAPTER FIVE

Once you have established the look of the gallery, you might then allow the visitor to either click on the images on the walls to open up a larger version of the image or merely move from page to page to see all the images in the exhibition.

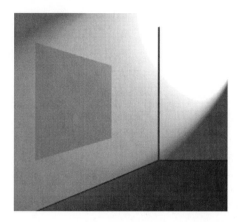

Photoshop finished drawing of your virtual gallery with lit walls.

Whichever way you decide to use, be sure to let your viewer get a feeling for the ambiance you wish to create in your gallery. You can be as literal or suggestive as you wish, but try to make the viewer understand something about how your work would look in exhibition rather than merely on a computer screen.

If your site is a book, how do you let the viewer understand the flow from the pages? Will your book only be linear—one page to the next? Or will you make a variety of possible routes to the pages? If this is an artist's book that is not narrative with a linear flow, the ability to take a variety of routes through the book might be desirable. You should ask yourself if it is imperative that the visitor sees each and every page to understand the concept behind this book, or can there be many concepts with the viewer controlling his or her own flow of information? With these ideas in mind, you can design your book to follow select patterns of flow. You might think about children's books where the page is cut into three sections, allowing the viewer to flip all or one of the parts to create a new image. Your web book might be like that with endless variations, or it might be more traditional with the flow being linear from page to page as in the book that Jan Ballard created first on paper then adapted for the Web. Her wonderful book *Girls with Skills,*

allows for a linear flow from page to page with the viewer clicking on each page to turn to the next. You can see Jan's book at *http://www.wwnet.net/~jballard*.

A page from Jan Ballard's web book, Girls with Skills.

Some books that ultimately are housed on the Web began as multimedia projects to be shown on a computer screen and then were ported to the Web for a more mass audience. When considering your book, go out onto the Web and search for others to examine.

If your site is an extended resume, how will you tell your visitor that you are a professional without saying that in so many words? Will you show examples of your work from various projects, with a variety of styles that reflect your clients' tastes, or will you make your extended resume eclectic, showing your own style boldly? If you are looking for a professional position, you might want your extended resume to exclude some information that might be considered personal, like any mention of your family, hobbies or friends. This resume will concentrate on your skills, creative ideas, and potential. If you are looking for a gallery or opportunities to exhibit your work or teach what you know, you might want to concentrate on your artwork, skills, and potential for sharing these things with others. If you want to give an overall well-rounded view of yourself, then including personal information might be the key. Just consider for whom the site will be geared and design it accordingly by including and excluding specific things.

And if your site is a research project, will you show diagrams and illustrations of your project's research subject? If your research project is breaking new ground in your specific area, will you be willing to share it freely with anyone who visits your site? This is a real concern for scholars who may wish to later publish in print this original research. If you share it freely, as you would on the web, there will be no control over who sees and uses your information. Putting copyright information on the material is a very good idea, but you will have no way of enforcing your rights. So, if you do the research project website, you may not want to include all your information but rather summarize what you have researched and some of the conclusions you have made. The visitor can contact you to either purchase your published material from print sources or you might want to leave the visitor with the summary only. Whatever your intention, be sure to put your bibliography on the website along with the material so that you are citing your sources.

On each level of the site, there should be clear, consistent navigational indicators on each page of that level or "chapter." You do not want your viewer to have to decipher the system for navigation on each page but rather to clearly see what it is. You want your viewers to spend time on the content rather than trying to figure out how to move around. Try not to wear your viewer out with too much information on each page. Make sure the graphic elements are reasonable and can be understood. Make sure the type is readable and not too small or strange for understanding to take place.

Also remember that children may visit your site. Recognizing that, you may want to show some restraint in what you choose to post. If there are things in your portfolio that may raise some eyebrows, indicate that with a warning to the viewer. I am not saying you shouldn't put your beautiful drawings or photographs of nudes online, but if they are graphic in nature, give a warning before you let the viewer see the images. You may also want to put something in the text about the nude in art over time in art history, if you feel that this would help to clarify your work.

This brings up an issue that was covered elsewhere in the book but is important enough to be brought up again. If you use historical art references in your website to put your work into a context and if you have "appropriated" images from another site, such as a museum, you must use bibliographic footnotes to let the viewer know where the images are from. If you use an image of someone else's work on your site, you must get permission to use it.

To begin your website, it is usually easiest to begin with the first page. Most people will call that page the index page. It will be named index.html. If you use that name, then when the viewer goes to your site, he or she does not have to type in the name of the first page but only the folder where the site exists. For example, to go to my website at the university, the address or URL (universal resource locator) is *http://www.nku.edu/~houghton.* If I was to use other than index.html as the first page, I would have to write: *http://www.nku.edu/~houghton/ firstpagename.html* to get to the first page of my site. It is more time and keystroke efficient to use index.html because you don't have to mention it in the address.

On this first page, you want to let the visitor know that this is the opening page of the site. You will introduce the navigation system that will help the visitor to understand how to move through your pages. On this first page it is good to have a link to your email address and other major pages within your site. If you don't have all the pictures or graphics at hand as you start, put place holders in the page to indicate where you intend to replace the place holders with images. Place holders can be empty graphical boxes that are specified to be replaced by graphic images.

Even if you cannot complete the entire opening page, do the parts of that page you are sure of, and then move on to another page. When you make the links to the other pages, make sure you write them down on your site map so that you will remember what to call all the other pages as you design them. The most common problem with new sites is not having the names of the buttons match the pages that they point to. It is much easier to do it at the point when you are first writing and designing the pages than it is to fix them later. So make sure you are careful with the spelling of the page names.

One pointer for the naming of pages is to keep everything in lowercase and also remember that you cannot use any spaces between the words in the name. If you want spaces you will have to use the _ between words. It is better to have your pages named in eight or less letters. This is because PCs using older systems cannot read the newer longer titles as on the Macintosh.

As you work make notes for yourself either in a notebook or on the site map pages about what you think you need to do. You will be working on a few parts of the site simultaneously, and it is hard to keep it all in your head and organized without notes.

When you begin your website, organization is crucial. If you don't do it at the beginning, it will make creating your site much harder and confusing. Remember, titles for the Web can have NO spaces in them, nor can they have any slashes or any other characters except the tilde (~), underscore (_), hyphen (-), or period (.). Since many servers are case-sensitive, it is preferable to use only lowercase when titling everything you do for your website. Because of the case sensitivity, a server will not be able to find a page or element that is titled *page.html* if the button that links to it is called *Page.html, page.HTML,* or the like. Keep track of the names for every image and page you create. If you keep a notebook, indicate in it which parts are going to be used on each page. For large sites, you may want to make folders for each page and begin to store all the elements that you collect in that folder, then when you begin to assemble, you will know where to find the parts that you need.

When scanning images and saving them for your website, place them all in one folder so they are easy to find until you know where they will go, then move them to the appropriate place. Make sure that you give your images the correct extension with the name, such as .jpg or .gif at the end. Keep the titles one-word names, or titles with no spaces. Keep them short—eight characters or less.

If you are working in a program that will not allow for the creation of buttons, effects, or graphics within it, then make folders for buttons, headlines, pictures, and text and place those folders on the same disk as the website will be when it is created. Make sure the names of the elements will tell you what they are for ease of use when making your pages.

When you begin to make pages, carefully name them and keep track of the exact name you give them. Again, keep the titles one word and short—eight characters or less. Put all the created pages in one folder along with the other elements for those pages.

Remember these important points:

1. Use only lowercase letters in your titles.
2. Use short titles with either one word or titles with no spaces.
3. When saving pages created in programs like LiveMotion, the software will add .liv behind the name for the editable file and .html when you export that file for the Web.
4. Always put the extension behind images and page titles, such as .html or .jpg.
5. Always keep track of what you name your elements.

6. You can use only the ~, _, -, or . in your titles for files or images.
7. You can use numbers and letters only in your titles, images, or file names. You cannot use any colons, semicolons, bullets, or apostrophes.

SHORT WEB CREATION PROGRAM TUTORIALS

IMAGEREADY AND PHOTOSHOP

Photoshop 5.5 and newer versions came with ImageReady, a program developed by Adobe for making images ready for the Web. In this overview, we will not go into detail on the many and complex ways Photoshop works as a standalone image editing and creation program. Photoshop is an amazing piece of software with more functions than most people will ever use or understand. For our purposes here, we will look at an extremely limited part of Photoshop and talk about how it will be used with such programs as Adobe's LiveMotion, and ImageReady for our web pages.

After you create original images for your website with Photoshop, you may need to resize them to fit on a 13-inch screen without cutting off any of the image. You may need to sharpen them with the filters. You may need to adjust the brightness, knowing that images often appear somewhat darker on a PC than on a Mac. And you will need to save them either as a GIF, JPEG, or one of the other web-ready formats.

Photoshop toolbox bottom showing Jump to ImageReady.

The new interface shown in the version 5.5 of Photoshop has additions to the already complex toolbox. At the very bottom of the toolbox is a new tool that allows you to jump to ImageReady as well as a new menu item under **File** called **Save For Web**. These allow you to preview and save your image with choices in size, format, and quality.

In each of the frames, you see the statistics for quality and download time with a choice of modem speeds and file size. You can choose which seems best for you by clicking on the image and then saying OK. Each of the images shows a slightly altered version. The detail in the face gets softer and less crisp as the quality goes down. You can compare it to the original image and make the decision about which is best for your purposes. Images are saved as JPEG, GIF, PNG8, or PNG24.

This feature is quite handy to use to make the image the highest quality with the least amount of download time possible. Let's say that you want to have a small button in LiveMotion with this image that, when clicked, would open up a large version. You would want an optimized image that was web ready for the larger version. That way, you could assure that it was downloaded in a reasonable amount of time so that your viewer did not lose patience and move on. Looking at the times based on the 28.8 modem speed will tell you a lot. You want those viewers with the slowest modem speed to enjoy your website as much as those who are on a

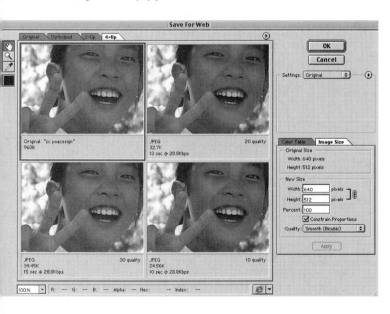

Save For Web in Photoshop brings you to this window in ImageReady.

very fast modem, a cable modem line, or a very fast and direct ethernet T1 connection to the Internet, as found at most universities.

Once you have decided on the best possible image and said OK, then you will save the image into your website folder.

PHOTOSHOP SCANNING

To create images for the Web, you might want to use a flatbed scanner to begin. Select the image that you wish to scan into the computer and lay it on the glass on the scanner. Make sure that the image is flat on the glass to avoid distortion. Using Adobe Photoshop, select **Import** under the **File** menu and then select the **Scanner** from the submenu. This will bring up the scanner software window on the screen. Select **Preview.** Drag a marquee around the image you wish to scan, and select the resolution you wish. I suggest scanning at a higher dpi than what you will use for the Web to have a crisper image to begin with. Choose either RGB or Grayscale and the scale that you desire. Then click the **Scan** button. Your newly scanned image will appear in a new window. At this point, you may need to adjust the image levels so that the image has a good spread of tones. You may also want to adjust the image size and the resolution of the image. When you use the **Image Size** menu, if the **Height** and **Width** are linked together, when you change one of them, the other will automatically adjust. You will want to keep the image in proportion. To adjust levels go to the **Image** menu item, then to **Adjust,** and then select **Levels** in the submenu. This will bring up a window with sliders that will let you adjust the blacks, midtones, and whites

Photoshop File > Import > Twain Acquire brings up the scanner preview window.

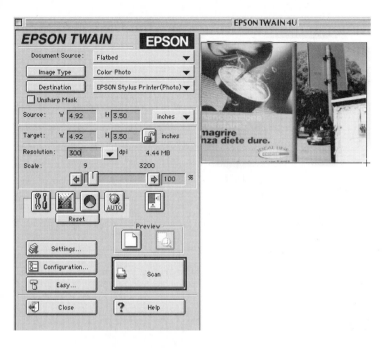

Epson Twain scanner window from an Epson Perfection 1200 scanner.

In Photoshop, once scanned the image appears in a new window. You can adjust it from inside Photoshop.

Photoshop Image > Image Size window.

Photoshop Image > Adjust > Levels.

Photoshop Levels adjustment window.

Photoshop Curves adjustment window.

incrementally. If you like what you see, select the OK. To make finer adjustments to the image, select **Curves** under the **Adjust** submenu.

In that window, position your cursor over the diagonal line and drag it up or down to adjust the tones. Move up the diagonal to get the high tones and down the diagonal to get the darker tones. When you like the way the image looks and have adjusted it properly, then it is time to **Save for Web** under the **File** menu. Selecting **Save for Web** will bring you to the ImageReady part of the Photoshop program where you can see the image as it would be saved in the GIF or JPEG format at a variety of quality levels.

Photoshop File > Save for Web.

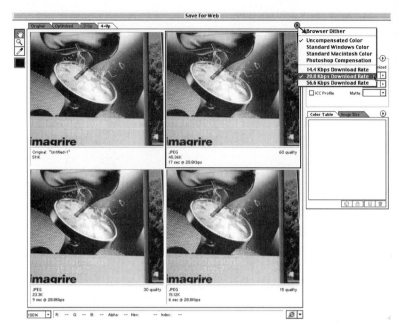

Photoshop Save for the Web brings you into ImageReady where you perform the save.

You can decide if you want the image to interlace if you save in the GIF format, but the GIF image will be made up of only 256 or fewer colors. Interlacing means that the image will load every other line at a time, which, in effect, makes the image appear to come into focus as it is loaded. Once the image is saved for the Web, you can import it into your web program to use.

It is important to remember that web pages with images take time to download so the image size needs to be reasonable or no one will spend the time waiting. The viewer has a short attention span. In ImageReady you can check out the download times for images in each preview window. Pick the preview that looks the best and has the short- est download time.

Photographs look best in JPEG format because JPEGs can have millions of colors and the transition between tones is more gradual, making the images look sharper and more defined.

First we looked at scanning pictures with the flatbed scanner. An- other way to import images into Photoshop is to scan your slides with a special slide scanner. This works similarly to the flatbed scanner with the exception that the image used is transparent rather than opaque.

Some flatbed scanners have attachments for scanning slides or transparencies or they have built in compartments for this task. Usually these flatbed scanners with slide attachments cost more than a regular flatbed scanner. Slide scanners cost more also and are limited to the size of image that can be scanned.

Still another way to import images is to have your film translated onto a PhotoCD at the processing lab. If you choose to do this, it is then only a matter of opening the image in Photoshop and adjusting the size and quality for use on the Web as with any other scanned image and re-saving it as web ready.

Digital cameras also offer a quick solution to collecting images for web pages. From your digital camera, follow the downloading directions from the manufacturer and then open the image in Photoshop to make it web ready.

As you begin, create a folder on your zip disk or hard drive. If you are using the lab computers, create this folder on a new zip disk. This folder will hold your website as you develop it. You can name this folder whatever you wish but a simple name is best for the website. Now, open PageMill and go to **Preferences** in the **Edit** menu. When this window opens, click on the **Server** icon. It will open a window like this:

ADOBE PAGEMILL

PageMill Preferences window.

Fill in the name of your server and location of your website on it. My server is *http://www.nku.edu* and my website is located in a folder or account on that server named houghton, so it looks like this: *http://www.nku.edu/~houghton*. Then double-click the folder icon below that. This will allow you to browse to the folder you have created on your zip disk or hard drive and highlight it. Then select **Choose**. This will then point PageMill to your local folder for saving and testing your website as you create it.

You can also fill in other preferences while in PageMill. You can decide if you want a constant background color, a special color for links, or to make the extension .html or .htm. Again, if you are working in the university computer lab, these preferences should be set each time you begin to work on your website because they will be particular to you. If you are working on your own computer, then they can stay the same from day to day.

To begin a new page, select **New** from the **File** menu. A new page will appear; unless you set the preferences for the background color, it will be a gray blank new page. Gray is the default color of the background for pages in PageMill. Enter the name of this new page in the **Page Title** box. Then go to the **File** menu and select **Save Page As**—if this is the opening page in your website, name it index.html.

PageMill File > Save Page As.

PageMill Title for page and saved opening page as index.html.

Make sure you are saving it into the folder you have created for your website. Once it is saved, begin to add the text and images you wish to use on this page. After you have worked on the page and are satisfied, save it. Adding text is very similar to working with a word processor because you type directly onto the page. You can change the typeface and its size by using the tools on the horizontal toolbar at the top of the window. However, unless your viewer has the typeface you choose, a default font will be used on the viewer's computer.

When you want to add images onto your page, you have a few choices. You can go to the **Insert** menu and select **Object** and then **Image** in the submenu; you can select the small **Object** icon on the toolbar and then browse to find your image; or you can simply drag the image onto the page. Remember that the image has to be either a JPEG or a GIF image to make inserting it work. If it is not, it will give you either a strange underlined word or a broken picture icon with a large

PageMill Insert > Object > Image.

PageMill Insert Object from toolbar.

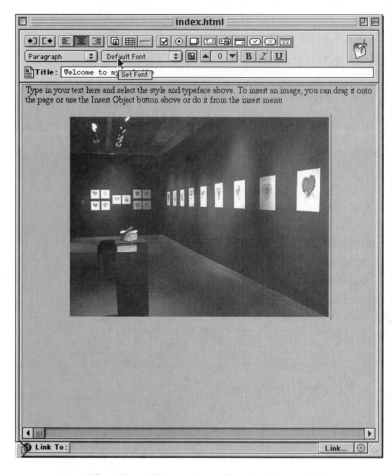

PageMill window with image inserted and ready to set the font.

question mark. If the image is too large for inserting because you have not saved it in a web-ready format, then you may get this error message. Once you have inserted the image, you can select how you wish it to be aligned by using the type alignment tool on the toolbar.

When an image is inserted, you may wish to make it an image map with hot spots that act as buttons to links on other pages. To do so, you need to double-click on the graphic to select it and display a new set of tools at the top of the window. If you click on the icon that looks like a small picture, you will get a working window that will allow you to draw lines around the part of the image that you wish to use for a button.

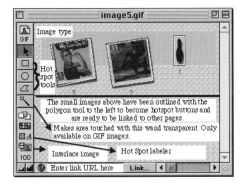

PageMill image window allows for making imagemaps and other changes to .gif images.

You can also label the hotspot with a name or leave it numbered. The labels will be invisible to the viewer but helpful to you if you are working on the code or don't have a graphical browser. Once you have drawn the boundaries for the hot spots, then you can link them to the destination pages by either typing the URL into the **Link Box** at the bottom or dragging and dropping the link page into the link box at the bottom of the window. Remember to save your page again. PageMill will generate a **PageMill_Resources** folder when it saves or generates GIF images or imagemaps. Make sure you move this folder, which appears on the hard drive, to your zip disk or all you have done will be lost. You will need to upload these resource files onto the server when you upload the HTML files. (See the section on Fetch for information on this process.)

The **Inspector** window allows you to assign attributes to pages, frames, images, and forms. With that menu you can tell the program

PageMill Inspector window.

Attribute Catagories Tabs

Insert background tile or image

PageMill Inspector window showing various options.

how to make frames or tables look or what action to assign to forms among other attributes.

You can link your pages to one another in a number of ways. One way is to select the image or text by clicking on it, then type in the link information (URL or other page in your site such as nextpage.html) into the **Link To** field box at the bottom of the PageMill window and then hit the Return or Enter key on the keyboard.

PageMill linking by typing in URL.

Or you can select the text or image and then drag and drop the HTML page from the Finder in the Mac onto the selected text or image. PageMill will automatically generate the link information. You can also link a button on one page to another this way: By placing two pages on your screen so you can see both clearly, select and drag the small page

CHAPTER FIVE

icon from the destination page to the link page. PageMill will automatically generate the link in the coding.

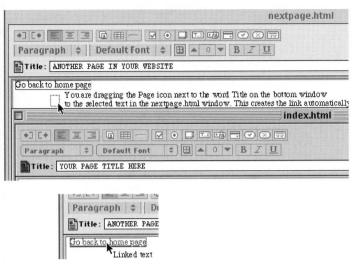

PageMill showing linking by dragging Page icon onto selected text to create the link.

You can also import objects such as QuickTime, Shockwave, and Flash movies as well as Acrobat PDF files and sounds onto your PageMill pages. PageMill may not recognize the file you are importing, but it will make a place for it on the page and in the HTML code that is generated.

To insert an Adobe Acrobat PDF file into your web page, proceed as though you were inserting a graphic image. From the **Insert** menu select **Object**, and from the submenu, **Acrobat File**. A tiny version of the Acrobat file will appear on the page. You will need to resize it by

PageMill Insert > Object > Acrobat File.

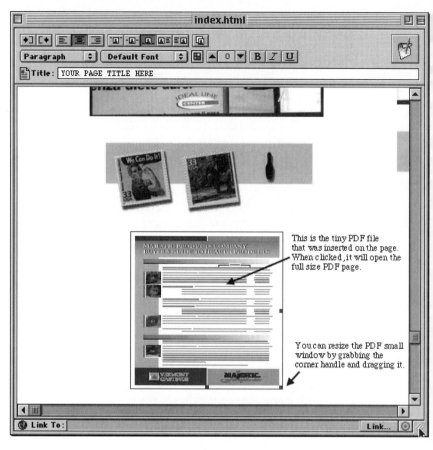

PageMill then inserts the Acrobat PDF file into the document as a small version. When clicked on, it opens up the larger document.

selecting it and dragging the resize handle of the graphic box until it is the size you wish. You must have the PDF plug-in installed in your browser to view the image on the page.

Adding other media types to the pages is done the same as with the Acrobat PDF file. PageMill will let you place these files and will generate the HTML code to accommodate these additions. If you need to adjust the code, you can access it through the **View Source Mode** menu item or make changes in the Inspector window.

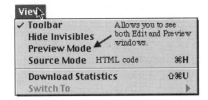

PageMill View > Preview Mode or View > Source Mode.

Sounds are harder to work with because PageMill does not support sound. You will have to edit the HTML source file to accomplish this. You can make a link to a sound file outside of PageMill by using a hotspot or other link.

You can do many more advanced things with PageMill, and I suggest you consult one of the manuals or excellent books on PageMill that are available commercially. PageMill also includes Help files with the program; you can find out more advanced techniques there.

When you are done creating this page, remember to save it and move all of the images into your website folder if they are not there already. Don't forget the PageMill Resources folder from the hard drive.

PageMill will create a PageMill_Resources folder that you need to move to your zip disk from the hard drive of the lab computer.

ADOBE LIVEMOTION

When you open a *new* LiveMotion window, notice the fact that you are given a choice of the page size before you can do anything else. Remember that with all web design, you should take into account the viewer that has a 14-inch monitor and design your website for those folks so that they don't have to scroll in two directions to be able to see your creation. The most appropriate size for your page for these monitors is about 580 × 450, especially if the viewer's monitor is set to a low resolution. You want to leave room on the viewer's small screen for the navigational bars built into the browser programs. You will also choose how to export the page. You can choose between **Entire Composition** for Flash animations, **AutoLayout** for static pages and more, and you can

decide if you want LiveMotion to write HTML when doing so. You can also go back to these settings later while the program is open by choosing the **Edit** menu, then **Composition Settings**.

Once the Composition window is open, you will see the toolbox on the left side of the screen. It looks like the following diagram. The topmost box shows the **Render Indicator**. When it is moving, the program is working on a task you have sent to it. In other words, if you are reloading a page, you will see the little spaceship flying along until the page is loaded onto the screen.

render indicator

selection tool

drag selection tool

rectangle tool

ellipse tool

pen tool

text tool

crop tool

paintbucket tool

hand tool

foreground background color

color scheme

edit mode

sub group selection tool

layer offset tool

rounded rectangle tool

polygon tool

pen selection tool

HTML text tool

transform tool

eyedropper tool

magnifying tool

preview mode

Toolbox for LiveMotion.

As indicated in the diagram of the toolbox, there is a **selection tool** and then two **subgroup selection tools**. One is for selecting an object when more than one is positioned over the others—like when you put text over a button. If you are trying to select the type and not the button, you would wait until the button, when positioned correctly, turns from the solid black to the greyed arrow to know that you are over a subgroup object. If you are over the selected object or within its bounding box, the arrow will change from black to grey to show that you are positioned over any object except the main selected object. Bounding boxes are the outlined boxes that appear around objects when they are

selected. A bounding box will not necessarily follow the exact shape of the object within it because bounding boxes are squares or rectangles only and the objects may be any shape. Bounding boxes also take into account any drop shadows or effects that may have been applied to the object and therefore take up more space beyond the object.

The **layer offset tool** allows you to move a layer or sub-layer in the composition screen or window rather than having to use the Layer tab window. So this means you can offset a layer visually or you can do it numerically on the Layer tab window. It is usually easier to make very small adjustments with the numerical adjustment in the tab window and larger movement with the visual method. You must remember to have the layer you wish to move or offset selected in the Object Layer window.

There are **rectangle, ellipse, rounded rectangle**, and **polygon tools** that let you create objects or combined objects right in the Composition window. These tools can be used to create buttons or place holders for the insertion or replacement with pictures or illustrations imported from outside LiveMotion. When using a rectangle with the **Replace** command, the image you are bringing into the rectangle will be automatically resized to fit into the rectangle that has been selected. With tools built into LiveMotion, you can also construct complex shapes from these tools by using the **Objects** > **Combine** > *options* menu. By overlaying the various shapes you create in the Composition window, you can **Unite, Unite with Color, Minus Front, Intersect** or **Exclude** portions of the shapes as they overlap and by doing so create new and exciting shapes.

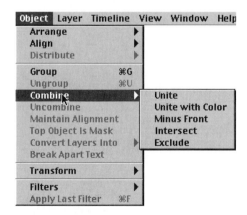

Object menu showing the Combine options.

Those familiar with Illustrator will find the **pen selection tool** in LiveMotion very helpful. With the pen tool, you have all the controls necessary to create paths, Benzier curves, and also to edit any and all of the anchor points. This is vector-based drawing just like you found available in Photoshop and Illustrator.

The **text tool** will also be familiar to you. As in other Adobe programs, you can use whatever font and style you have available on your computer. It will not make a difference if the viewer of your website has the same typeface because once saved as HTML files and uploaded onto your website, the typeface is embedded into the web page as a graphic and therefore your pages will always look the same no matter what computer they are viewed on. For artists and designers, this is very important when planning out how you want your site to look and how you want it to communicate to the viewer. When the typeface and style cannot be controlled, the best design elements can be radically changed if a substitute typeface is inserted on the viewers' computer, leaving you no control over how your website looks to others. When your time has been spent carefully planning and executing your website, you would like others to see it as you planned. Many of the more sophisticated web design programs now have this feature available, but none so easily usable as in LiveMotion where not only can you use a variety of typefaces, but you can apply the styles to the type right on your screen in the program. So, that means that you can type the words you want to use and then apply drop shadows, emboss effects, and color without having to leave the program. When using other web programs, you have to move to another program to create the type if you want special effects applied to it, and then when finished with your style applications, return to place the text. In LiveMotion the process is direct and quick.

The **HTML text tool** is new in LiveMotion. It allows you to place HTML code that you write or that you import from other places into your page. This is especially good if you want to insert plain text into your composition. Say you have a long written piece that you want on a page. If you type it in using the type tool and save it as you normally would, LiveMotion would convert that text to a graphic image and save it that way. Graphic images take up more space than text saved in plain HTML format. This would keep your file smaller. In order to use the HTML text tool, you must export the file or composition as the AutoSlice or Auto-Layout option. The HTML text tool is not supported by the Flash file format, so you cannot use this tool for compositions that are animated with the Flash capabilities of LiveMotion and exported as Flash files.

To use the HTML text tool, you would select it and then drag a rectangle for the code to be inserted into on the composition screen. When you double-click the rectangle you have drawn, you can then insert the code or save that for later and use this as a place holder for that code.

The **crop tool** will be familiar to those who use any other Adobe products. It is used to crop images after they have been placed in the Composition window. It works differently than in Photoshop, but is easy to use. By placing the crop mark over one of the corners of an image, you can slide the marker down to crop what is not wanted from each of the corners of the image.

The **transform tool** is also new in LiveMotion. Photoshop has some very complex transform options, but most of these are not available with this tool. You can skew and rotate objects with it by moving to the appropriate anchors or corners of an image.

The **paintbucket tool** is also familiar to those who know Photoshop. It works very simply by filling selected areas with the foreground color.

The **eyedropper tool** allows you to select specific colors from the Composition window to use as the foreground color. It is a handy tool that is used in most of the other Adobe programs.

The **hand tool** is also familiar to all Adobe users. It allows you to move objects around on the screen of the Composition window when the visible window is smaller than the actual window size. The hand tool allows you to scroll around without using the sliders.

The **magnifying tool** allows you to zoom in on an area of the screen of the Composition window to work in detail on objects.

The **foreground** and **background colors** are changed by using the color tab menu window, but the colors are shown here in the large boxes. You can toggle between foreground and background colors.

The **color scheme** tool is new in LiveMotion and is very interesting because it allows you to store and lock in colors that will be used throughout your website. This means that you don't have to go back to a former page to reselect a color for type or background to bring to the page you are working on. With this handy tool, these colors can be decided upon and then locked into this palette for ease of use throughout the entire website design. Using consistent colors will help you to make your site have the same feel no matter what page you are on. You can choose as many as six colors that you wish to lock into your color scheme palette. You can also decide how close you want the colors aligned in the color wheel. When your decisions have been made, then

you can lock in the colors so that they cannot be changed when working on the site. To select colors to begin your color scheme, simply take the eyedropper tool onto your design and select a color. This will automatically be brought into the Color Scheme tab menu and then it will begin to find aligned color for you.

LiveMotion also allows you to look at the work you have done in both the **Edit** and **Preview** window modes. You can also preview your work in a browser. Using the preview window mode is helpful to check on roll-over effects and to view your animations.

BEGIN MAKING LIVEMOTION WEB PAGES

Choose **New** from the **File** menu to open the **Composition Setting** window. Choose **AutoLayout** from the popup choices and check **Make HTML**, then say OK. Your new Composition window will appear. Make the background black by opening the **Color** window in the **Windows** menu, selecting the rightmost large box in the two boxes that sit overlapping on the left side of the window. This is the box that sits behind the other box. After selecting this back box, then move the eyedropper over to the black in either larger color area or the white-to-black sliding scale next to the larger area where the cross hairs appear in this diagram. Clicking on this will turn the background in the Composition window to black.

LiveMotion Color tab window.

Next, move back to the Composition window and then to the Toolbox. Select the **text tool** and move onto the Composition window and place the cursor in the upper left corner and click. This will bring up the **type tool** window. In it, you will select the typeface, style, size, and alignment that you desire, then type your name. Use at least a 24 point type size. Change the color of your text by selecting it within the Composition screen and then, using the **color tab** window, select the foreground color box (the front box). Find a suitable color to move the eyedropper onto and click. Automatically your type color will change.

Now open the **styles tab** window from the **Windows** menu. With the text box with your name in it still selected, find **Emboss** in the styles, click on it, and then select Apply. This will make your name appear to be embossed on the screen by adding the shadow and highlights to the text.

LiveMotion with Styles tab window Preview View showing Emboss being applied to text.

Now, let's change the background to white and see what happens when we apply a dropped shadow from the name. Go back to the **color tab** window and select the Background box, then go to the grey scale and select white. This will turn your background to white. Go back to the Composition window and select your name. Then go to the **styles tab** window and select **Drop Shadow** and **Apply**. This will put a shadow behind your name. You can adjust how this looks and where the shadow sits behind your name by going to the **Window** menu and then bringing up the **Object Layer** tab window. Select the shadow layer. Then open the **Layer** tab window from the **Window** menu and use the sliders on the X-Offset, and the Y-Offset and the Softness slider to adjust how the shadow looks in the Composition window. When you are satisfied with the look of your shadow, then move on to the next exercise. You will see that when you applied the shadow, the emboss effect went away. If you wish to put it back onto the type, select the 3D tab behind the **Layer** tab window. First, select Layer 1 from the **Object** layer window that shows your name. Select **Emboss** from the popup selections. You can then adjust the depth, softness, lighting, and angle of the light for the text.

For the next part of this exercise, we will place an image from Photoshop into our Composition window. Find a Photoshop image that is no larger in physical image size than about 4 × 5 inches. Make sure that you have already made it web ready in Photoshop with the

Save for Web features that we talked about earlier in this chapter. Now, go to the **File** menu and select the Place command. Browse through your files until you locate the image that you have prepared to import and then select **Open** in the browsing window. It will bring the web-ready image into LiveMotion. If the image was flattened, the layers will not be available. If it was not flattened, you could use this image later for an animation exercise.

Now resize this image to a take up about one-half of your available screen. To do this and keep the proportions fixed, hold down your shift key as you drag the image from the corners. When this is done, you can place a drop shadow under the image like you did with your text by going to the **Styles** tab window and selecting **drop shadow**. Adjust your shadow the same way you did with your text.

Next, go to the Tool box and get the **rectangle tool**. Make a small rectangle somewhere in the Composition window. With that rectangle selected go to the **File** menu and select the Replace command. Browse for the image that you have just placed in the composition and replace the small rectangle with that image. Notice how it automatically resizes the image and fits it into the box. If the proportions are really very different, it might distort your smaller image or slightly trim it from the edges. This is how you would make thumbnail images for a gallery page or index of your images. You could use the small thumbnail image as a button.

Click on the larger image and select your Delete key on the keyboard. This will leave you only the name and smaller thumbnail image on the screen. Move the image to a space below the name you have placed in the upper left-hand corner of the screen. With the thumbnail image selected, duplicate it by either using the key commands ⌘ and D or by using the menu **Duplicate** commands in the **Edit** menu. This will make a duplicate image of the one on the screen, placing it on top of the one already there. Duplicate this image four times, then drag those images out in a horizontal line. Now, with the shift key down, select all of the images. Another way to do this is to have the arrow or selection key at the top of the toolbar selected and then drag a box around all of the images. This will select them all. Now that they are all selected go to the **Object** menu and select the **Align** command and then **Top**. Next, select **Distribute** from the **Object** menu and then **Horizontal** to align the objects and distribute them evenly across the window using the end images as the boundaries.

To change the images within each of the duplicated rectangles, select one at a time then go to the **File** menu and select **Replace**. You can

then browse for the next image you wish to place in this box. Once all of them have been replaced, you can assign URLs to them to have them act as buttons. To do this, select one of the boxes and, from the **Window** menu, select the **Web** tab window. In the window write the address of the page where the image will be. It will be an address like *image1.html* for a web page with this image. If the image is going to be shown in the enlarged version alone without a page, it will have an address of *image1.jpg*. If it is an image that is not in your website folder, it will have a full http web address.

Save your page as a LiveMotion file with a .liv behind the name. Bring up the Export Settings window and set the top pull-down menu to JPEG with quality to 50. Next export the page to HTML by choosing **File > Export As**. Before you save, make sure that the destination folder is the folder you desire by using the small hand pointing tool at the top to bring up a popup menu and choose the destination folder. That will generate an *images* folder and the HTML document. Both of the parts will be uploaded to your server. The images will need to be in an *images* folder inside your web folder on your server.

Using the page from the previous exercise, open the .liv page. Go to the **Composition Settings** in the **Edit** menu and change the settings to **Entire Composition** from the popup menu and leave the **Make HTML** checked. Say OK.

Now with your page and the four images on it, let's see how to do a simple animation of the images. Open the New TimeLine window in the **TimeLine** menu. It will show you the four images as items in the window. You will rename these objects so you can keep track of them while you animate. To rename one of the objects in the TimeLine window, select it and then hit the Enter key (not the Return key) on your keyboard. This will bring up the Name dialog box in the figure below. Do this for each of the picture objects in your Composition window, naming them object1, object2, object3, and object4.

To animate one of the small thumbnail images, select it in the Composition window and then move to the TimeLine. In the Time-Line, click on the arrow next to the highlighted object to open up its submenus. Then click on the arrow next to **Transform** to open up its submenu. Click on the stopwatch next to **Position** and that will put a keyframe on the TimeLine. Now drag the **Counter** tab at the top of the window to 1 second and that will open up the TimeLine. Go into the Composition window and drag the selected object down in the window.

ANIMATE YOUR PAGE IN LIVEMOTION

LiveMotion showing animation layers from Photoshop and the Rename Selection dialog box with the TimeLine.

You will see that another keyframe is put into the TimeLine and that the sliders have opened up. You will also see an elastic line being drawn from the old position on the Composition window to the new location in that window. This is the motion path for the image.

LiveMotion showing the TimeLine and the Transform>Position change.

104 CHAPTER FIVE

To play the action you have just set up, you would either go to the **Preview View** on the Toolbox or use the VCR control buttons on the TimeLine. Now let's change its Opacity from the beginning of the movement down to the bottom. So, we need to reset the action to the 0 point on the TimeLine. This can be done by either using the VCR control buttons by clicking the one furthest left, or by simply dragging the **Counter** tab back to 0. Then click on the Opacity stopwatch to put the keyframe out on the TimeLine. Drag the **Counter** tab out to 1 second and then using the Opacity tab window from the **Windows** menu, drag the opacity slider to 50. You should replay the action to see if you like it.

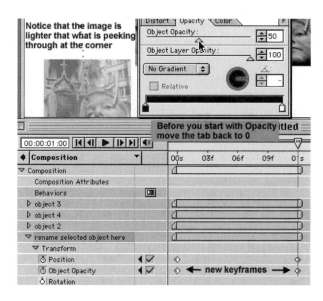

LiveMotion showing the TimeLine and the animation with the new Transform>Object Opacity selected and acted upon.

Do the same with each of the other images in the Composition window, but change the location where you drag the images. Play back your results. You can change any of the other attributes in Transform and in the Object Attributes or Layer portion of the TimeLine, but for our purposes, we will leave those alone. Once you have animated the images, you can decide if you want the animation to loop or to just play once. If you decide to loop the animation, go back to the TimeLine and click on **Composition** at the top of the TimeLine window just below the VCR controls. Now go to the **TimeLine** menu on the menu bar and

down to **Loop**. That will put a curly loop symbol on the TimeLine next to the behaviors symbol to indicate that it will now loop.

Save this changed composition as some other name for the .liv file. Then open the **Export** tab window and set the first popup menu to **Flash** and leave the other one at .jpeg then save the image. It will select **Export** or **Export As** from the **File** menu and it will generate the HTML file and the .swf file to go with it. When you upload this to your server, be sure to put both in the .www folder.

<table>
<tr>
<td>

**ADDING SOUND
TO LIVEMOTION
COMPOSITIONS**

</td>
<td>

The **Sounds** tab window lets you apply sounds to your composition. You can add your own sounds or sounds supplied by LiveMotion. You can preview any sound by double-clicking it. To apply a sound to your composition, simply drag the sound to your composition at the point in the animation that you wish the sound to be heard. It will automatically be inserted into your TimeLine.

Sounds can be added to your **Sounds** tab window. You can use any .aif, .mp3, .wav, and .snd format sound by placing it into your sound folder inside the program. Then when you restart LiveMotion, the sound will appear in the palette. The sounds will be saved and exported inside your Flash file from LiveMotion and will not have to be uploaded separately.

</td>
</tr>
<tr>
<td>

CREATING ROLLOVERS

</td>
<td>

Rollovers are effects that are triggered when you roll the mouse over an object on the web page. It might be as simple as changing the text size, font, or color when the mouse is rolled over the object. It might be as complex as having styles applied to the object when the mouse is rolled over it. When the mouse goes off the object, it then turns back into its original state.

To create a **simple rollover** effect in LiveMotion, select the object that will have the effect. This is the object you wish to apply the rollover effect to, so go to the **Rollover** tab window and create a new **Rollover State** by selecting the icon at the bottom of the window. This will make a duplicate of the normal state. It will change the popup menu from **normal** to **over**. Once you have done this, go to the **Color** tab window and select the color that you wish to change the selection in your composition window to. This will show your change until you select the **normal** state again in the **Rollover** tab window. When saved, the button or object will change color whenever the cursor is rolled over it. You can also add more changes by adding more states to the rollover. You can make it turn still another color when you click the mouse down.

</td>
</tr>
</table>

CHAPTER FIVE

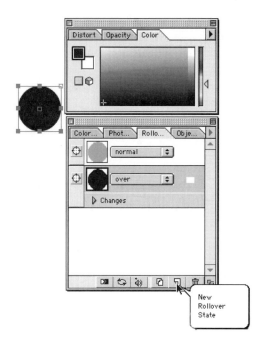

LiveMotion window showing the making of a simple rollover where the color is changed on the over state.

Remote rollovers are effects that are triggered by one object but affect a target object. The trigger object is the object that the visitor interacts with, such as rollovers with the mouse, clicks with the mouse, or points to with the cursor. The target object is the object that is actually changed or activated. It could be as simple as your pointing at a colored circle. When you do, a yellow square pops up elsewhere on the page. It could be that you roll over an icon or picture and text pops up explaining the image you have just rolled over. These rollovers are very effective ways of giving information or activity without cluttering the page. When overused, however, they can be tiresome and confusing.

 Creating remote rollovers is a bit more complicated, but they can be very effective on your web pages. You must prepare the target object before you can use it in a secondary rollover effect. Preparing the target object means you must create a custom state. Objects in LiveMotion can have as many states as you want them to have. These custom states will be beyond the normal, over, down, and out states. A custom state is merely a state that you have created and named in a specific way and

can use when you create a remote rollover effect or to assign custom be-
haviors to an object.

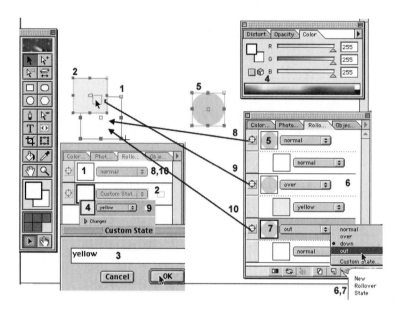

*LiveMotion with various tab windows showing steps for a more complex rollover—
the Remote Rollover. In this rollover, when the mouse rolls over the circle, the yel-
low square appears in the window.*

Follow these directions and look at the diagram for clarification for
remote rollovers.

1. Create WHITE SQUARE in composition window. In Rollover tab
 window, you will see that as the normal state.
2. Create NEW ROLLOVER STATE for the white square. Select
 CUSTOM STATE from the popup menu.
3. Name it YELLOW in the popup dialog box.
4. Go to the Color tab window and select yellow with the eyedropper
 tool and the white square will change to yellow in the custom state.
5. Create a GREEN CIRCLE in the composition window. In the
 Rollover tab window, you will see that the normal state is a green
 circle.
6. Create NEW ROLLOVER STATE for the green circle for the over
 state.

CHAPTER FIVE

7. Create NEW ROLLOVER STATE for the out state.
8. Go back and select the white square and select the normal state in the Rollover tab window. Now go back to the normal state of the green circle and drag the target to the white square in the composition window. It will create a substate for the normal green circle that is the normal state of the white square.
9. Go back to the white square and select the custom state of the yellow square in the Rollover tab window. Now go back to the green circle and select the over state in the Rollover tab window. Drag the target icon over to the yellow square in the composition window. This will create a substate for the over state of the green circle.
10. Now go back to the yellow square, select it, and then go to the Rollover tab window and select the normal state again to make the square go white again. Then move back over to the green circle and select it and then go to the Rollover tab window of the green circle and select the out state. Drag the target icon over to the white square in the composition window and a substate will be created below the out state.

When you are finished with this, go to the **Preview** finger icon at the bottom of the toolbar and preview your remote rollover. You should see that when you move your mouse over the green circle, the

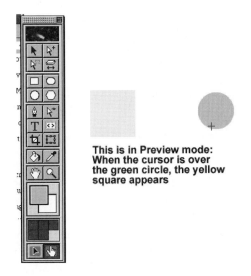

This is in Preview mode: When the cursor is over the green circle, the yellow square appears

LiveMotion window showing the cursor over the circle making the square appear.

yellow square will appear. When you move it off, the yellow square will disappear. In reality, the white square appears when you are not on the green circle, but you cannot see it because your background is white.

Open a new LiveMotion Composition window from the **File** menu. With the **rectangle tool**, draw a rectangle in the window. Using the **Transform** tab window, make the height of your rectangle 50 and the width 180. Now select the **ellipse tool** and create an ellipse that is 206 width by 125 high. Move that ellipse so it sits on the top of the rectangle. Now make a circle with the **ellipse tool** by holding down the shift button while drawing the circle. Make that circle 212 wide by 212 high. Place that circle on the bottom of the rectangle so that it overlaps until the circle fits into the edge of the rectangle. Make all of the shapes the same color from your Color Scheme colors and then select all of them. From the **Object** menu select **Combine** and then **Unite**. You have just made a shape that looks similar to the Pillsbury Doughboy's head.

LiveMotion showing a shape made by using the Combine and Unite commands in the Object menu.

I suggest that you spend some time playing with the other options in the **Combine Object** menu. You can make shapes for navigational bars, images, and control panels. Use your imagination and try applying styles to your shapes to see what you can do. Remember that while working in LiveMotion, all things are editable and save all the changes. This feature is handy for creating navigational bars with complex shapes and buttons.

After you have made your pages in LiveMotion, you can export them as HTML files with either *images* attached or with *flash* files attached. If you have created a page with no animation, and it could include rollovers, then you would set the **Export Settings** menu to JPEG. The Composition settings must be set to AutoLayout with the HTML option checked. This would export the HTML file and the images files. If you are exporting a page with a Flash animation on it, you would set the **Export Settings** menu to **Flash** and it would export the HTML file and the .swf. The Composition settings must be set to **Entire Composition** with the HTML option checked. When you upload these files, make sure you put the images into the *images* folder inside your web server and that you also put the .swf files in the same folder with the HTML files.

LiveMotion Export Settings Window picking the JPEG option to save static pages to HTML and sliced images to be reassembled on a web page by the browser.

LiveMotion Export Settings Window picking the Flash option to save static pages to HTML and the .swf files to be reassembled on a web page by the browser.

As you open GoLive, you will be presented with a new window and two floating windows. The first thing you will do is to create a new site. You will go to the **File** menu and then select **New Site** then **Blank**. This will bring up a window allowing you to give your site a name.

GoLive new window.

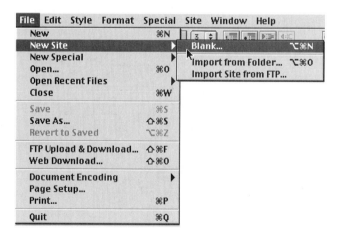

GoLive create new site.

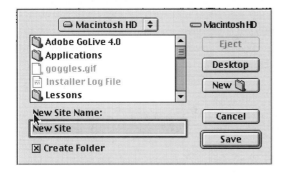

GoLive give your site a name.

GoLive creates this site folder. A. Folder where all your pages and other media for your site will be stored. B. Site data folder contains Components, Site Trash, Stationeries. C. The site with the symbol pi file, which is used to read the structure of your site.

You can then go to the Finder in your Mac and find the new site folder that was created with the name of your site. It will be the holder of your entire site. Not all of the items in this folder will be uploaded to the server, but all of it is important to you. Within this site folder you will find one folder that will have the site's name on it. This folder will hold all the pages, images, media, and other parts of your site that must be uploaded. Another folder will have the name followed by the .data designator. This folder will hold data like Site Trash, Components, and Stationeries. The other file in the site folder will be the site directory. GoLive automatically creates these folders when you name your new blank site. It also creates the first page of the site, the index.html page.

This page is put into the folder with the site's name on it; it will also hold all the rest of the pages.

You can view the directory for your site in the site window available within GoLive.

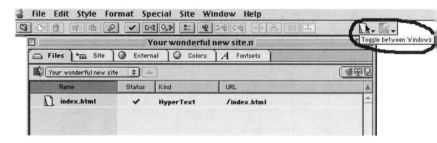

GoLive your site window.

To see this site window, use the toggle window button on the GoLive toolbar. This will toggle you between whichever page you are on in the site and the site management area. When you are in the site, you can choose between the available tabs. These will let you see the files, site map, and many other controls for the site. In the **Files** tab window, you will put all the resources that you plan to use on your site including the images, buttons, saved animations, saved headline graphics, and so on. To do this, go to the **Site** on the menu bar and then to **Add Files**.

GoLive Site Menu > Add Files.

GoLive Files to Add to Site.

You will browse and locate the folder with the files you wish to add, then add them to the site, either *en masse* or one at a time. GoLive will make a copy of these files to add to the site window, leaving the original untouched. When you are finished, or at least for the time being, select **Done**. Your files will be placed into the site **Files** window where they will be available for placement onto your site's pages.

GoLive Site window.

You can organize that files window by adding new folders from the toolbar on GoLive and then moving the files into the appropriate

folder. This way you will be able to easily find the files when needed. If one of the files you upload is from an imported site, you may find that there are some links that are incomplete or some files that may have problems. If this is the case, you will see a bug icon next to the file in the Status column or next to the folder that contains one or more files with problems, also in the Status column. Later I will talk about fixing the bugs.




ASSEMBLING THE SITE
THE SIMPLE WAY




Now that you have placed the files you want to have available to work with in the site **Files** window, you will click on the **Toggle** window button to go back to the index.html page or double-click the index.html icon in the site Files window to open it. You begin to assemble the elements to make your page. You need to change the title of the page by highlighting it and putting in what you wish to appear at the top of the browser window when the page is displayed online. Decide whether you wish to use the default window size of 580 pixels wide. This size will insure that the web page will fit on a 14-inch monitor. Since many of your visitors will have a 14-inch monitor, this will enable them to look at your pages without scrolling. You can choose other settings by using the pulldown menu at the bottom left of the window. The next thing you should do is decide if you like the default background color of light gray or if you wish to change it. In order to change it, you will need to bring the inspector up in your window. To open the inspector on a Mac, select the command key and the number 1. If the inspector was already open, it may be seen as the text inspector. To change it to the page inspector to adjust the color of your background, simply click on the small page icon next to your page title. You will see the text inspector change before your eyes. When you click in the background color, it will automatically bring up the color palette and the original background color will be in the large upper window. Select the color you wish for your background from the palette. Then drag that color over to the page inspector window and let it go on top of the background color swatch. It will automatically change the color of the background on your web page to your new desired color. And it will put a comment at the top of this page that says Color. This will not show up in the browser, so do not worry about it. Another way to change the background color is to select the color desired and then simply drag it onto the page icon next to the page title. This will automatically change the selection in the page inspector. To collapse the color menu so it is no longer in the way, hold down the Control key on the Mac and click




once on the top title bar of the color window. You can do this with any of the inspector windows to collapse them. To reopen them simply go to their small icon, either drag or click, and they will open again, as if by magic. This way, you can have them handy but not blocking your valuable working space.

Click in the page window and the cursor will begin to blink. Simply type in anything you wish. After doing so, select the type and decide the attributes you wish to give it.

GoLive Headers pulldown menu.

This illustration shows the HTML header styles and also the other attributes available on the toolbar next to the pulldown menu. You can see the highlighted text where the attributes will be applied. This is the simplest way to put type on the GoLive page. You can also import type from other programs as you would normally by copying and pasting into this window. This text is editable. Another way is to select it in another open document with the option key down, then drag it into the

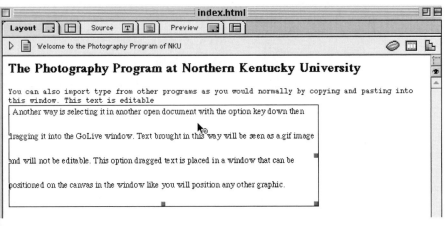

GoLive Import text as graphic element.

GoLive window. Text brought in this way will be seen as a .gif image and will not be editable. This option, dragged text, is placed in a window that can be positioned on the canvas in the window like you will position any other graphic.

To import graphics onto a simple page like this in GoLive, click on the **Toggle** window button to open the site files, then find the image you wish to put onto the page and simply drag it over to the page. With this method, you will not be able to position the image wherever you wish, but you can use the formatting tools to center or align left or right.

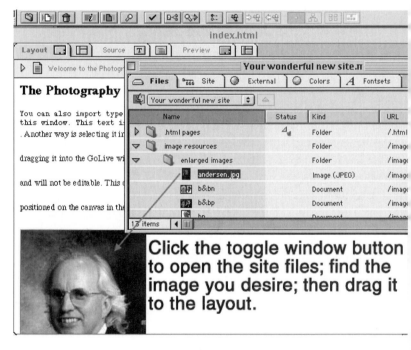

GoLive Drag graphic from Site window to page.

You can add design elements to this page by applying font sets to the type. Go to the page and select the Headline "The Photography Program at Northern Kentucky University." Once that is selected, you would go to the menu bar and then select the font set you wish to apply.

You will see that the default font changes to Arial from the new font set. If you then look at the source code, you will see that the directions in the source code telling all browsers to use Arial for this Header are written in automatically. If they don't have Arial, the browsers will go through the font set list and use whichever font is available on the viewer's computer from the list. If all fails, it will use the default font.

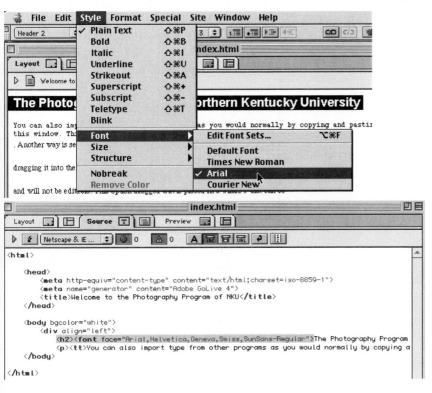

GoLive showing Font Set Arial and the Source code for that in the source window.

You can also create your own font sets by selecting the **Edit Font Sets** option under **Fonts** and then adding new fonts in groups to the dialog window.

GoLive Edit font sets.

The example in this window illustrates the fonts in the Arial font set. You can further enhance your simple GoLive page by placing horizontal rules in the page, applying other styles to the type, and more.

Links from your page can be set up with text or buttons. Buttons will be brought into the program as graphics and treated in the same manner as we treat the text links. With the text link, you will select the word or words that will be the link and then move up to the toolbar and click on the new link button. This will change the highlight of the selected text and change the text inspector to the link tab window of the text inspector. Here you will click the browse button and find the link target or you will type it into the URL box.

GoLive Create new link.

Beginning with an empty layout for index.html, go to the palette and drag to the layout window. A number will be assigned to the floating box and the inspector window will change to the floating box inspector.

ASSEMBLING SITE IN MORE CONTROLLED METHOD IN GOLIVE

GoLive Drag Floating Box.

GoLive Dragging Image Placeholder into Floating Box.

To reposition this box you must use the box handle on the left edge. To resize this box, click on the box and then use one of the resize handles on the corners. Anything can be put into this box. To do so, select one of the other icons in the Palette and drag it into that box. You can use the Image placeholder to put an image in this floating box.

After you put the image placeholder into the floating box, go to the Image Inspector and browse to find the image to go into the placeholder. You can resize the box to fit the image after it is placed. You can move the image to another place on the page with the Floating Box handle.

You can also put text into the floating box and move it around the Layout window. This way you can create complex designs with floating boxes overlaying each other. You can also link any element on the GoLive page to any URL or other anchor.

WORKING ON THE LAYOUT GRID FOR STILL MORE CONTROL

You can begin your web page design by dragging the Layout Grid onto your web Layout window. Once an element is placed onto this grid, it can be positioned anywhere and will hold its place. Without the grid, unless you are using a floating box on the page, you cannot control the location of the elements. They will stack up from left to right on the page. The Layout Grid gives much more control over all the elements and will allow the designer more freedom in the look of the page.

CHAPTER FIVE

GoLive using Layout Grid.

It seems that there is an advantage to making your elements live in floating boxes so that you can stack the elements on the page. The problem is that you cannot assign transparency to them, so when you stack them, they completely block out the elements underneath. If you want to have the transparency of elements in fact, you must work on them in Photoshop or LiveMotion and then export the entirety of the overlapped and transparent images as one graphic for use in GoLive.

GoLive with Stacked floating boxes containing elements created in LiveMotion, including their styles.

LiveMotion showing elements to import into GoLive: A. Circle placed over sheep's head in picture with magnifying glass style applied. B. Typeface control with drop shadow placed directly over the picture. C. Typeface control with drop shadow that falls on picture below. D. Picture with drop shadow.

GoLive with LiveMotion elements imported.

When you look at the difference between creating the elements in LiveMotion and then bringing them into GoLive as Trimmed Compositions and as .gif images, you can see the transparency showing up under the words at top. The grid shows through where the transparent part of this image lies on the page. I have added floating boxes around the imported LiveMotion elements to show that they can overlap and still be seen when you are using this method of working. The control over the typeface will be a big draw for artists and designers because no matter what typefaces are installed on the viewer's computer, the typeface will always look like what is seen here. This is because the typeface has been exported as a graphic element, thereby keeping all the design styles applied to it including the typeface, typestyle, and drop shadow. None of the imported LiveMotion elements will be viewed with translations done by the viewer's browser. This control will not be necessary on all pages you create but when you want that control, it is good to know how to do it.

We can also create many of the same effects in Photoshop and import those into GoLive. Again, the page section is imported into GoLive as an image rather than as text and image. All of the style applications like the drop shadows, opacity controls, and overlapping of text and image remain the same as they were on the Photoshop page. In order to create any links from this page, you would use the image map feature of GoLive to create hot spots.

GoLive showing elements imported from Photoshop as a .gif file.

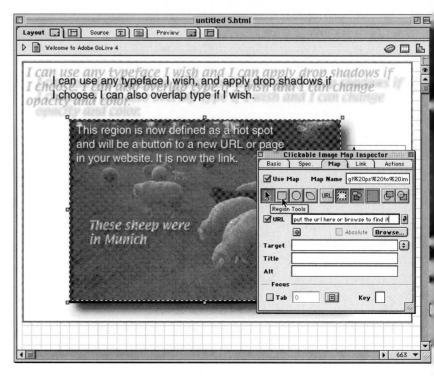

GoLive can make an image map from the Photoshop .gif import.

To create an image map for use as a button or link to another URL, select the image in GoLive; that should open up the Image Inspector. Select the Map tab to open up the Image Map tools. Select one of the drawing tools and use it to draw a shape around the area that you want for your new button. Then either browse to find the link or type it into the URL box. You cannot have overlapping buttons unless you bring each of the regions to the front and at least a good part is visible. If a button or region is completely underneath another region, you will not be able to get to the button or link to select it. When you save your document, it will save your image map.

ANIMATING ELEMENTS IN GOLIVE

In GoLive you can do simple animation using floating boxes and the TimeLine editor, and you can move elements along paths to add visual dynamics to your web pages. You can open the TimeLine Editor by clicking on the filmstrip icon at the top right corner of the layout window. This will open the TimeLine Editor. Now go to the Palette and drag a floating box out into the window. Put an Image placeholder into

he floating box. It is important that you always use the Image placeholder for your animations so that the animation is visible in both Netscape and Internet Explorer. Now go browse in your site files to find the image to place. Do not do an animation with the Layout Grid or Tables on the page because you may cause browsers to crash or freeze.

Once you have your image in the floating box, select it and give it a name in the Floating Box inspector. When you make a floating box, a layer will be created in the TimeLine. You will also see that the first keyframe is also created. Now move down the TimeLine. While holding Command key down, move your cursor over to a selected frame on the Timetrack and a keyframe will be inserted. Now go back to your Floating Box inspector and enter a pixel number and click on the little Enter button next to it. This will move your floating box with image over to that location on the screen leaving a grey trail behind it. You also must decide if you want a linear, curved, or random motion in your animation. You do this in the lower portion of the Floating Box inspector window. Play your animation by first clicking the stop button on the TimeLine editor to reset the counter to the beginning and then click on the play button to see your animation. To make a curved path, select a frame somewhere in your TimeLine and insert a keyframe by holding down the Command key and clicking in the Timetrack. Then move to the floating box, and with the handle, move this box to the desired location. You will see the path is now curved. You can add as many keyframes as you wish to make your animation. Make sure you test all animations in all browsers before uploading to make sure they work correctly.

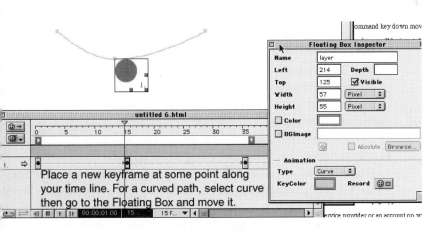

GoLive animating elements from other programs in floating boxes.

You can also use the **Random** path selection in **Animation Type** in the Inspector to create more random and jerky paths. When creating animations, more than one keyframe can be selected at a time to allow you to change the Animation Type all at once. To select more than one keyframe, click in the TimeLine editor and then click and hold down the mouse button. A crosshair cursor will appear and you can drag a box around all the keyframes that you wish to batch change to select all of them.

Another way to create paths in GoLive animation is to select the record button on the Floating Box inspector. Then, using the handle on the floating box, drag it around on your window and the path will be automatically recorded. When you have drawn the path out and stop, the record button will deselect and stop the recording action. You will notice that while drawing the path, many little grey ticks will be entered on the path line. These correspond to keyframes on the timetrack. If you need to edit the motion, you can select the keyframe you wish to change, then, using the handle of the floating box, drag the box to a new position.

You can also use the **Depth** box in the Floating Box inspector to determine which moving object will be seen on top when paths of moving objects cross. Likewise, you can control which objects are visible and when by using the visibility check box in the inspector. Remember that each object on the screen has a layer in the TimeLine editor. To change the visibility of objects, go to the TimeLine editor, select the keyframe where you wish to begin invisibility, then go to the inspector and uncheck the **Visibility** box. To keep the object invisible until you want it, you will need to duplicate that frame and then drag it out to the place on the timetrack where you want it visible. In order to duplicate the keyframe, you will hold down the alt key while you click on the keyframe. Then drag it out and you will see a duplicate of the keyframe. The duplicated keyframe will have the same attributes as the original one. In order to be able to have the keyframe reappear at the desired place, you will then go back to the inspector and recheck the **Visibility** box.

You may also want your visitor to be able to play and stop the animation on your page. You will have to use actions to do this. You first will create or import buttons that will say Play and Stop. First, select the Play button and go to the Image Inspector and select the **Link** tab. From the **Link** tab click on the new link button and then go to the **Special** tab and uncheck the border button to remove a colored extra border from around the button. Now move to the **Actions** tab, highlight the **Event Mouse Click!**, and then select Actions + button and move down to the **Actions** popup menu and select **Multimedia > Play Scene.**

From the **Scenes** popup menu, choose the proper scene, most likely, Scene 1. Now do the same for the Stop button, but this time in the **Actions** menu, choose + select Multimedia > Stop Scene. There are many more possibilities with animation on GoLive, but you should consult the user's manual or some good online tutorials for these. Always check the Adobe site online for these.

GoLive lets you to build web pages with forms that will allow the visitor to send information back to you. The forms work because a script is generated that tells the server what information to collect from your pages and then it sends it to you as an email. There are two parts to any form. One is the part that you can see on your web browser and the other is the part that sits on the server and uses a Common Gateway Interface (CGI) script to process the information and pass it along to you. You must find out from your web administrator if you have use of CGI scripts and if you can place CGI scripts on the server if necessary. Most web servers have these available in a database and your web page with the forms will call upon that database to serve up that script to process your form.

Let's create a form with GoLive. Write a header for your page. Then drag a Tables icon onto the Layout editor. Using the Table inspector, decide on the number of columns and rows you will need for your table and form.

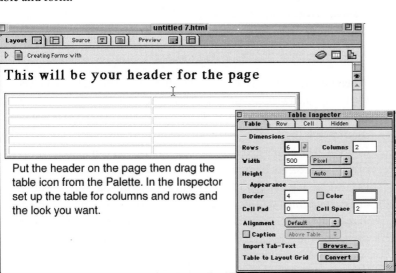

GoLive creating new form.

From the **Palette** in the **Forms** tab, drag the Form (F) and EndForm
(/F) tags to the new page with the Form tag before the table and the
EndForm tag after the table. Start entering the text that will be constant
on the form.

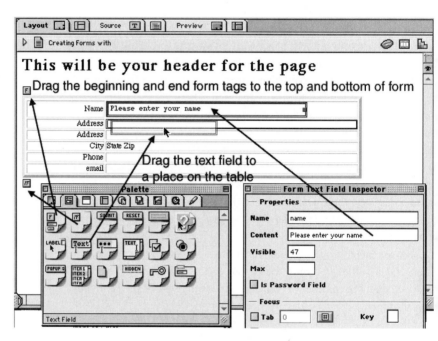

GoLive adding page tags and information.

When you have established the constant text on your form, you will
then drag form text boxes to the cells of the table where they belong.
When they are in place, you will need to fill in the Form Text Field in-
spector with the name of the field and any text you want to show in the
Content. The Name is very important so that you can identify the infor-
mation as it comes back to you when the form is submitted. You can
use text, popup, checkboxes, or radio buttons in your forms. But for
our current form we will just use the text field form. After you have
named all the form text fields and entered the content that you wish to
appear on the form in the form text box, you are then ready to add the
Submit and Reset buttons at the bottom of the form.

From the Forms Palette, drag the Submit and Reset buttons onto
the form or just below it like I did in the example.

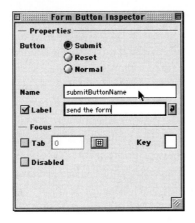

GoLive create a submit button for form.

This will be your header for the page

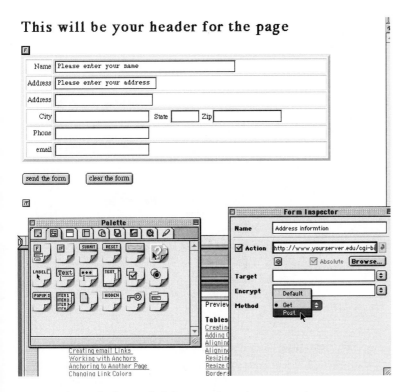

GoLive set the form to find the processing script at your cgi server.

Then bring up the Forms Button inspector, click on Submit, and name the button Submit. If you want the button to say something different than the default, then type it in the Label field and make sure the box by it is checked. Do the same for the Reset button.

Click on the **Form** tag to bring up the Forms inspector. In the inspector give the form a name so that you can identify it when it comes as email. Then check the Actions box and give the address of where the script lives on your server. You will get this address from your system administrator or webmaster. Put it in carefully exactly as they told you or your form will not be able to find the CGI database to locate the form processing script you are using.

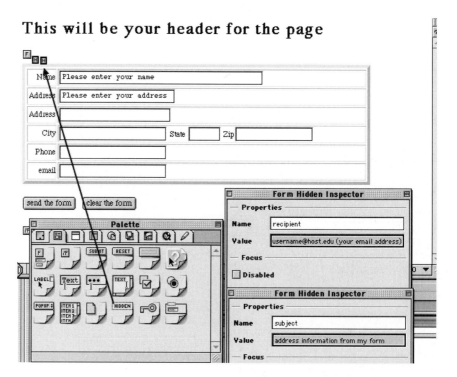

GoLive add hidden text to your page so that the form will be sent to a specified email address.

The next thing you must do if you want the form to work is to place several hidden fields in the form. These will tell the script where to send the form when processed as email and also will tell the email what the subject line will appear in the email. To make this happen, drag a

Hidden tag up to the area next to the Form tag at the top that will bring up the Form Hidden inspector. With the H still selected, fill in the Form Hidden inspector to Recipient for the name of one and then your email address or the email address that is to receive the form information. Then drag another Hidden tag up to the top next to the others and, with it still selected, fill in Subject for the name. Give Value some clearly identifiable phrase to fill in the subject line of the email that will be sent to you. This will help you identify all the email that will come to you from this form.

If your form requires popup choices, this is how the popup field works. Drag the Popup field onto your form and personalize it in the Form Popup inspector for your form. Select the label "first," which will appear in the lower boxes where you change the name and the value that will be sent to you in the email.

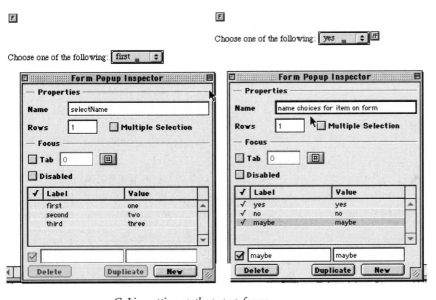

GoLive setting up the popup forms.

If you need to use a radio button in your form to choose between a variety of options, this is how the radio button field works. Drag the radio button over to your form and fill in the names of the choice. Duplicate the button and paste it in for the other choices. This will ensure that only one radio button can be chosen at a time.

GoLive using radio buttons in forms.

If you need to use checkboxes for multiple choices on a form, this is how the checkboxes work. Drag the checkbox onto your form and supply the names of the choices.

GoLive using checkboxes in forms.

You can specify which checkbox is selected or if any will be. Make sure you give the values for each choice along with the name so that you will understand your email when the form is sent to you.

If you wish to have a scrolling list with multiple choices possible, you will use the Form List box. This is how it works. Drag the Form List box to the page and then select each of the choices, changing their names and values so that you can understand the form information when processed. Make sure you have multiple selections checked. To be able to choose multiple items, hold the command key down when choices are made. You should put these instructions onto your page as instructions for the visitor.

GoLive using List in forms for multiple choices.

Photoshop, ImageReady, LiveMotion

Assemble nine or ten images of your work from slides, scanned images, PhotoCDs, or those created on the computer and saved onto disks. Using ImageReady and Photoshop, prepare these images for the Web as you have learned earlier in this chapter and save them into a folder on either your desktop or better yet, on a zip disk. Make sure that the image size is no larger than 6 × 8 inches and no smaller than 4 × 5 inches. Save the images as .jpg. If possible, make some horizontal and some vertical images for this exercise.

Next, write some text to go with each image in your notebook to use when assembling this web page. Make sure you say something

informative about each image and give the title, its size, the date it was done, the media used in the piece, and if it is in a collection whether private or public. You will use this information in remote rollovers on your page.

When all of this has been assembled, it is then time to open Live-Motion and begin to create your animated name for the headline on the page. This animation will feature each letter of your name being added one at a time as if it was being typed with an old-fashioned typewriter. Make sure you have a typeface like American Typewriter, Typewriter, or Courier in your font folder in your system. To check for the fonts in your system, hold down the mouse button in a program like Microsoft Word, point to the font menu, and it will display all the fonts. You can also go into your System Folder on the Mac, open the Fonts folder that is inside, and then look for one of the fonts I described. If you don't have any of these, find the font that most looks like something from the typewriter. You can also check out your fonts in LiveMotion by selecting the type tool and placing the cursor in the Composition window. When the Type window opens, you will be able to check for the typeface in the pulldown window.

Type tool in LiveMotion.

Now type the first letter of your name and say ok in the type tool box. Now open the Timeline and make that letter show up a few frames into the animation. Do this by dragging the timeline span slightly to the right. Now set the time with the Current Time Maker slightly to the right of the first letter's opening spot. Then type the next letter in your name in the window, positioning it next to the first letter. Move the Time Maker slightly for each letter and then add it to the Composition window. The effect will be that that of a typed name appearing in the window.

LiveMotion timeline adding animated letters of your name.

When you are finished putting in all the letters in your name, press the rewind button to set the timeline to 0. Then hit the play button to view your animation so far. Each letter should appear one at a time and then stay on the screen. If they don't stay on, make sure that each of the individual timelines is dragged to the right and that they all line up there.

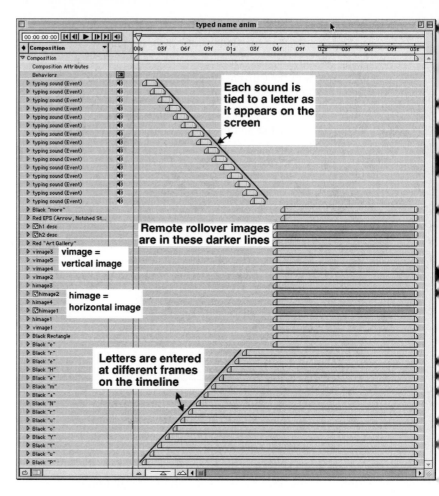

LiveMotion timeline showing animated name with sound and rollovers.

For the timeline above, your page should look like this. You will create placeholders for each of the images you will later place on the page. Set them up like the example with all the horizontal and vertical images in their own lines. Put the words Art Gallery under the images. Leave a blank space at the bottom of the page for the spot where your remote rollovers will show up when called upon.

In this assignment, you will make a page in LM you will create an animation of your name being typed in and attach sound.

Put Your Name Here

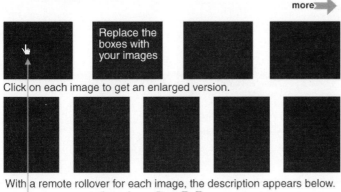

more

Click on each image to get an enlarged version.

With a remote rollover for each image, the description appears below.

Art Gallery

Description of this piece (H1) will appear in the space provided here. You should give Title, Media, Size, and date for piece. If the piece is already in someone's collection, then you should give that information by saying "From the collection of Their Name.

LiveMotion showing the placeholders for images for your gallery.

For any button or link from a page that is to be saved as a Flash animation when exported, you must make the links differently. Links in these instances must be done with behaviors added to the rollover menu. To make the link do the following:

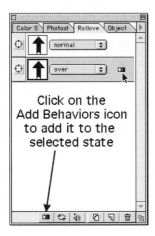

Click on the Add Behaviors icon to add it to the selected state

LiveMotion showing Add Behaviors for rollovers.

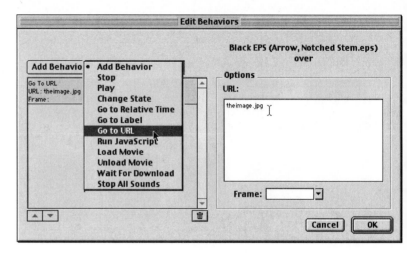

LiveMotion: When clicking the small icon at the bottom of the window, this window will come up, then Add Behaviors > Go to URL, and then add the URL of the image for the rollover.

- With the button selected, open up the Rollover tab window and select the over state by clicking on it. Then select the Add Behaviors icon from the bottom of the window.
- This will bring up a Edit Behaviors window where you will use the pulldown options to select Go to URL and fill in the URL in the URL window. Then select OK.
- This will make the link for the button on a page that has an animation and will be exported as Flash.

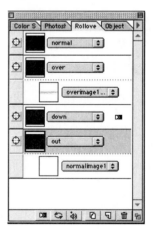

LiveMotion rollover tab showing various rollover states.

To create the text that will go with each image in your gallery, carefully follow these instructions:

- Select the button, open the Rollover tab window, and create a new state that will default to over. Create another state for down and one more for out.
- Create the written information for your image in a new text box. Create rollover states for this text. In the normal state change the opacity to 0. In the over state change the opacity to 100 using the Object Layer Opacity .
- You must select the over state in the text before you drag the target to it if you want this to work correctly. Click the over state to select it. Then take the Target icon and drag it to the over state of your text for image 1.
- You must select the normal state in the text before you drag the target to it if you want this to work correctly. Click on the out state for the rollover for the button, then drag the Target to the normal state of the text for image 2.
- Pick the Preview mode button and test your rollover for image 1.
- Repeat for each of the images.
- Test each image to see that the rollover works correctly.

Now add the sound to the animation. Using the timeline, move the Current Time Marker to the beginning of the timeline of the first letter of your name, select the letter in the composition window, then select the ButtonPush sound from the sound menu and click the Apply icon at the bottom of the Sound window. Do the same for each letter to apply the sound for each letter as it appears on the screen. The sound additions should be tested by clicking on the Preview mode icon in the Composition window. It should sound like an older electric typewriter.

Export your page as a Flash document with the Entire Composition selection in the Composition settings.

Photoshop, ImageReady, LiveMotion, GoLive

Gather images for your gallery into a new folder for assignment 2. Name this folder images2. Make two image sizes for this exercise. One should be small for the button; the other should be an enlarged size. Both should be optimized for the Web in Photoshop/ImageReady and saved at the best resolution with the smallest file size. Make a top left

corner section for this page in LiveMotion that says your name. Make two lines connecting at a right angle by using the rectangle tool and use the gradient tool to fill. Place these below your name and down the left edge of the page as in the example. Save this as a static .gif file and use the **export selection option** to save into your assignment folder. Next, make a button with some styles added to it to be used to move to the next page. Make sure you save the button image as web ready by using the export selection command.

Make a simple animation that will fit on your gallery page in Live-Motion, save that animation as **Flash** in the **Export** menu and as Trimmed Composition in the Composition Settings menu. Put that into your assignment folder also.

Open GoLive and it will open a new page automatically. Under the **File** menu select **New Site** and **Blank**. Name that new site assignment2. Then move over to the **Site** menu and select **Add Files**. Browse and put all the files you have collected from Images 2 into your Assignment 2 folder into this site window for this assignment. Now toggle between the site window and the gallery page. Make sure you change the title of the page to Welcome to My Art Gallery.

Assignment 2 toggle in GoLive between windows.

Using the floating box from the Palette place a box on the page and then put the Image placeholder into it. Browse for the name and gradient line image. Next place another floating box and put the More button in it and then another for the Art Gallery words. Make a floating box with an Image placeholder for each of the images you will put onto this page to be filled later. Next, make one more floating box and place into it the Plug-in holder. Then browse to find the Flash animation that you made in LiveMotion. Fill in the images in the other boxes. Save your page and preview it in your browser. Now go back and make all the links using GoLive's Link tab in the Inspector. Save again and preview again before you upload it to your website.

Assignment 2 GoLive window.

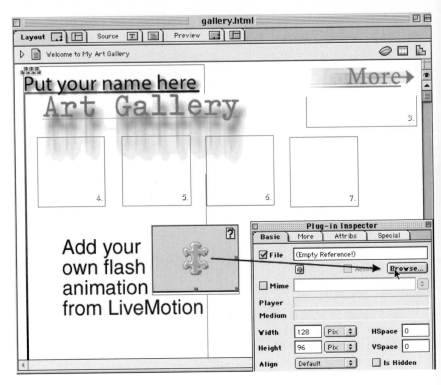

Assignment 2 Add LiveMotion flash animation to your GoLive page.

URLs Used in This Chapter

- Kelly Grether: *http://home.earthlink.net/~gretherk*
- Jan Ballard: *http://www.wwnet.net/~jballard*

6

UPLOADING YOUR FINISHED PAGES
ONTO
YOUR SERVER
AND
TESTING THE SITE

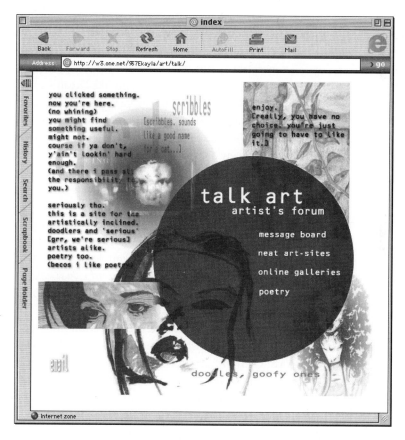

Nicci Mechler's Art Talk Forum at http://w3.one.net/~kayla/art/talk/.

UNDERSTANDING THE DIRECTIONS FOR UPLOADING SITES

LiveMotion

LiveMotion will make both static pages, those without animation, and dynamic pages with animations. Static pages will be saved as .html and will create an *images* folder on your disk with all the .jpg images inside. These are the parts of each page and will be identified with the name of the page at the beginning of the name of the part. The contents of the *images* folder will be uploaded into an images folder that you will create from inside of Fetch or Voyager on your server. Read the directions for Fetch or Voyager for specific directions on how to do this.

If you created dynamic or animated pages, they will be saved as .html and .swf files for the animation. Both the .html file and the .swf file will be saved in the www folder. Nothing will go into the images folder from the dynamic pages.

Other Programs

If you created a site with GoLive or other web page creation programs, you will have files with .html and graphics used on the site with either .gif or .jpg. Do not confuse these graphics files with those that are created in the LiveMotion program. These graphics files have been created separately by you and are not generated by the program you are using. GoLive and other Web programs like Dreamweaver, HomePage, and PageMill do not generate image files when you save the page. They will only create an .html file, which will have pointers that will tell the browser to load the graphic files. The graphic files will be created in ImageReady or Photoshop and then uploaded to the www folder.

FETCH FOR MACINTOSH SHORT TUTORIAL

After finishing your website pages, you will want to place them on your server. If you do not have a service provider or an account on your school's system, you will not be able to do the following exercise. Make sure you have an ftp program like Fetch to use to upload your pages to your account on the server. If you don't have Fetch, you can download a free copy from this web address: *http://www.dartmouth.edu/pages/softdev/fetch.html#News*. Install Fetch on your computer and then follow the exercise below.

Open Fetch. Select **New Connection** from the **File** menu, bringing up this window where you will enter the host, userid, and password for your account. If you do not have a www directory in your account yet, you can leave the directory box blank for now. Then click OK.

Fetch will go look for your personal account on the server and then open up this window if you have left the directory window blank. If not, it will open into the www folder window.

Fetch New Connection window on a Macintosh.

Fetch window when connected to your server showing the www folder.

For those who do not have a www folder, make a new directory to go inside the main window. To do this, under **Directories** menu, select **Create New Directory**. Name that directory www. Next, double-click on the new www directory folder and it will open a window with www in the box directly over the list of the contents of that window. All you have to do then is to drag the .html files into that window and they will automatically upload for you. If you have any other image or graphics files that were not generated by LiveMotion, such as the larger versions of some buttons that you will show, drag these .jpg or .gif images to the same directory where the .html files are found. With Flash files from

CREATING THE WWW
FOLDER AND UPLOADING

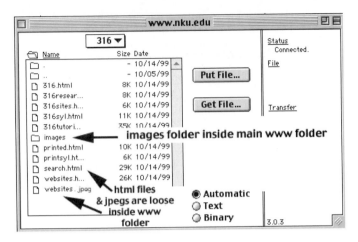

Fetch showing inside the www folder and inside another site folder called 316.

LiveMotion, you must drag the .swf files to the same folder as the .html files. Do not confuse these with the image files generated by LiveMotion when exporting your web page. These images files will go into a different folder inside the www folder.

CREATING THE IMAGES FOLDER AND UPLOADING

If you used LiveMotion to create your web pages, you have to create an images folder to go inside the www folder in the site window. Go again to the **Directories** menu, select **Create New Directory,** and name that one *images*. Double-click on the new images folder in the site window to open it. Make sure it says *images* in the pulldown box above the contents on the site window. Now go to where you have saved the website pages on your hard drive or zip disk and open up the images folder there. Drag its contents into the fetch images window to begin uploading all these image files.

When all the images are uploaded, quit Fetch and test out your site using your browser. If you have difficulty getting the entire web page image to show up or load, you will have to increase the allotment of memory given to your browser program. Ask your teacher or lab manager how to do this.

Once again, for uploading website pages and images done in programs such as PageMill, GoLive, Dreamweaver, and so on put all the .html, .jpg, .gif, and .swf files in the www folder.

1. Start FTP Voyager. A window called FTP Voyager Site Profile Manager should appear.
2. Click the New Site button in the window. In the FTP Site Profiles list, you should now see a new folder with the name Site # (where # is just a digit).
3. In the Name: field on the right half of the FTP Voyager Site Profile Manager window, type a descriptive name for the FTP site you will be connecting to. For example, if you are entering NKU's hostname, type nkuwww for the site name.
4. Type the actual FTP site in the field labeled FTP Site:. For example, NKU's host name is www.nku.edu, and NKU's FTP server site name is ftp.nku.edu.
5. The Description and Default Directory: fields are optional, and you do not need to include any information in these fields.
6. Click the box next to Anonymous Login: so that the check mark does not appear. The User ID: and Password: fields should now be active.
7. FTP Voyager will remember all the information you have typed in, excluding your password. If you want FTP Voyager to save your password so you don't have to type it in every time you use the program, click the checkbox next to Save Password so that a check mark appears.

CONNECTING TO A SITE

1. Start FTP Voyager. A window called FTP Voyager Site Profile Manager should appear.
2. From the FTP Site Profiles list, click once on the site to which you want to connect.
3. Type your password in the field labeled Password:.
4. Click Connect in the upper right-hand corner of the Site Profile Manager window.
5. You should be logged in within a few seconds.

UPLOADING

1. Connect to your host.
2. Locate the file you want to upload, drag it up to the remote host window, and drop it in the appropriate directory.

DOWNLOADING

1. Connect to your host.
2. Locate the file you want to download, drag it down to the local host window (the window that shows the files and directories on your computer), and drop it in the appropriate directory.

Renaming and Deleting Files

DELETING FILES

RENAMING FILES

1. To delete a file, right-click on the filename.
2. A popup window will appear with a list of choices. Choose Delete.
3. FTP Voyager will ask you if you want to the delete the file.

1. To rename a file, right-click on the filename.
2. A popup window will appear with a list of choices. Choose Rename.
3. The file will then be highlighted and you can rename it just as you would in the Windows95 Explorer, and so on.

TESTING, CRITIQUING, AND EVALUATING WEB PAGES

Once all of your new pages have been put up on the server, it is time to test them. Make notes about what looks good, what doesn't, what works well, what doesn't. Test each button to make sure it goes to its intended page. If it doesn't, figure out if it was a mistake in naming the page or the button. This is easily fixed. Ask yourself the following questions:

- How does your new site work? Be critical.
- How does your new site look? Be critical.
- Do all of the images load at a reasonable rate or do you have to wait a long time for some?
- Do all the images load all the way?
- Can your new site be viewed equally well on Explorer, Netscape, and other browsers?
- What problems do you see? How will you address them?
- How well do the pages reflect your intentions?
- Can someone else navigate easily through your site? Get a friend to test it without any coaching.

It is common to have changes to make on your pages. When you make changes in the LiveMotion files, don't forget to re-export the files and upload all the .html and image or .swf files again. If certain images won't load when looking at the page in your browser, go back and look at them carefully. Make sure you did not save them in the wrong format. Make sure you did not forget to drag them to the folder when you were uploading.

An important thing to remember is that every time you upload a file with the same name as one that is already up on your server account folder, you will replace the old with the new. However, most servers keep more than one version of a file, so at some points, your account

may be full from all these extra versions of files. You should contact your system administrator to find out how to delete or purge these extra versions in your account to make room for more pages. Each server has its own protocol for doing the account maintenance and for uploading files. Make sure you find out all you need to know about your own server before you begin. Usually there is something posted on your server's homepage with directions for putting up homepages or websites. Follow those directions carefully.

Now that you have saved your pages in HTML from LiveMotion, you can open that HTML page in Adobe's PageMill or another simple web program or source editor. In PageMill, under **File** select **Open,** then Open. A window will appear and let you choose the page you wish to work on. A LiveMotion-created HTML page will look very funny in PageMill because the page will look all cut up or part of the page won't show up at all. Don't worry. Ignore how it looks here just give your page a title in the little box called **Page Title**. This will then appear at the top of the page when opened in the browser. Save the page in PageMill or your other edit program.

REFINING AND REGISTERING THE WEBSITE

USING PAGEMILL OR OTHER PROGRAMS TO GIVE YOUR PAGES TITLES AND EDIT THE SOURCE CODE

PAGE TITLES

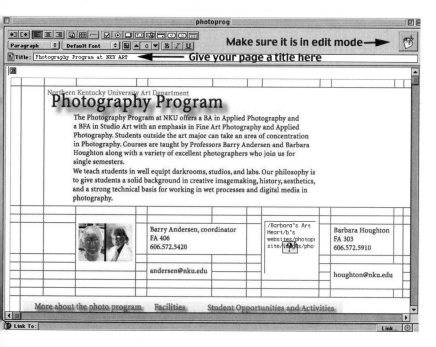

PageMill being used to put in the page titles.

Search engines look at source code of your web pages for keywords, page titles, and what is in the first paragraphs of any text found on the page. The search engine uses this information to help find you more quickly. If you are careful in the way you put in this information, you have a greater likelihood of having your pages show up earlier on the search engines. Sites with a businessname.com show up faster more often than websites like my site because it is a subset of the university's website. So, artwork-inform.com shows up before *www.nku.edu/ ~houghton.*

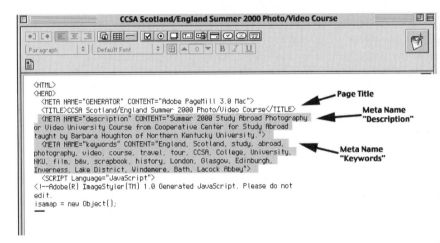

PageMill being used to put in the keywords while in the Source Mode.

You can help your site to show up by the addition of keywords to your pages. To do this in a program like PageMill or another source code editor, select the **Source** view. In PageMill, go to the **View** menu and then select **Source** mode. Insert into your source code at the place shown in the example below after the <HEAD> tag.

```
<HTML>
<HEAD>
<META NAME="GENERATOR" CONTENT="Adobe PageMill 3.0 Mac">
<TITLE>CCSA Scotland/England Summer 2000 Photo/Video
Course</TITLE>
<META NAME="description" CONTENT="Summer 2000 Study
Abroad Photography or Video University Course from Coop-
erative Center for Study Abroad taught by Barbara
Houghton of Northern Kentucky University.">
```

```
<META NAME="keywords" CONTENT="England, Scotland, study,
abroad, photography, video, course, travel, tour, CCSA,
College, University, NKU, film, b&w, scrapbook, history,
London, Glasgow, Edinburgh, Inverness, Lake District,
Windemere, Bath, Lacock Abbey">
<SCRIPT Language="JavaScript">
```

In this example, <META NAME="GENERATOR"CONTENT=
"Adobe PageMill 3.0 Mac"> is telling us that the source code has been
generated by PageMill. It tells us that the page title has been specified to
read "CCSA Scotland/England Summer 2000…." It tells that by using
the <META NAME="description" CONTENT="Summer 2000 Study
Abroad Photography or Video University Course from Cooperative
Center for Study Abroad taught by Barbara Houghton of Northern
Kentucky University.">, we have been able to insert a description of the
page for the search engines to pick up that reiterates the page title. In
your META NAME description, you can write whatever descriptive
narrative you wish the search engines to read. This will appear in the
search engine after the page title. For the <META NAME="keywords"
CONTENT="England, Scotland…">, we have included all the words
we thought people would ask search engines to find when trying to find
a site like ours. These are the words you would write into the little
search box on a search engine. It is important to note that repeating the
same word more than three times can cut down on the effectiveness be-
cause it causes the repeats to cancel out the word.

Remember that the keywords are words that people might use
when they ask a search engine to find a site. Do not repeat your key-
words more than twice or they tend to cancel each other out. Separate
each word with a comma. In the "description," use a short description
of the site and end it with the >, using no space between the final word
and the >. Make sure you enclose all that is between the < and > in
quotation marks.

Most search engines allow you to register your site with them. It takes
up to a month for your site to show up on some search engines. Go to
the search engine and look for the place on the page that says something
like "Add Your Page." Below is from AltaVista:

*About AltaVista | Help | Feedback | Advertising Info | Add a Page
Disclaimer | Privacy | Copyright | International | Set your Preferences
When you get to Add a Page follow their simple directions.*

REGISTERING THE WEBSITE

Step by Step: Integrating Image and Idea on Your Web Pages

After you have created all your images and made a flowchart, do the following:

1. Create Website folder on zip disk or hard drive.
2. Save all images that will be on your website in web-ready format using Photoshop and/or ImageReady. Images will most likely be GIF or JPEG format. Make sure they are not too large to load in a reasonable amount of time.
3. Using LiveMotion, create canvas size.
4. Using LiveMotion, select background color.
5. Using LiveMotion, create templates for your site pages with similar page for each level.
6. Save LiveMotion template files.
7. Using LiveMotion, import images by either using **Place** or **Replace** command.
8. Resize or move images to desired location on page.
9. Using LiveMotion, type in your text and apply color, style, and type size.
10. Create buttons, arrows, or links using Shapes from LiveMotion or use Photoshop to create new button images.
11. Make links from selected buttons or text by entering the URL in web window in LiveMotion or ImageStyler.
12. When each page is complete, use **Export As** in LiveMotion to generate the HTML page and image or flash files. Make sure you export to the website folder you have created. Also, make sure you have set your export settings to the desired quality.
13. Using Fetch or an ftp program, upload your website to the server. Make sure you put a www folder in your main account, and then make sure you put an *images* folder in the www folder. Put all the html and extra images in the www folder and put the contents of the *images* folder generated by LiveMotion in the *images* folder that is inside the www folder on the server.
14. Test the site by clicking each and every button and also going to each page in the website.
15. Correct any errors and inconsistencies you found in your testing.
16. Have a friend or critic test out your site and give you feedback.

17. Make keywords and enter them into the source code for the main pages. Reload those pages.
18. Register your site with search engines.

URLs Used in This Chapter

- Nicci Mechler: *http://w3.one.net/~kayla/art/talk/*
- Fetch: *http://www.dartmouth.edu/pages/softdev/fetch.html#News*

7

PROJECTS
FOR THE
WEB

Gabriel Romeu's Journal of Observations website at http://members.xoom.com/gabrielR/.

Having gathered your skills, you will now embark on the project phase of your web design. You should use all your creativity to complete a website that shows off your individuality and freshness. Your project will reflect your best efforts and ideas. Use the tools that best suit your task. You have studied tutorials on a variety of programs. From those that you have studied, and those that are available in your lab or on your home computer, decide which will solve the problem the best way and which you feel will show off your site.

Select one of the ideas—Creative Expression: e-artist book; Self-Promotion: expanded resume or exhibition on-line; Research and Presentation: art historical research project with illustrations and writing; or Creating an Artists' Community: website for club, group, or society—and use that to guide you to complete a website.

Remember to:

- Make a list of ideas that you wish to communicate.
- Transfer those ideas to self-stick notes so that you can use them to make your site map for the project.
- Make notes on the site map so that your ideas are recorded and can be referred to when you are working on the site.
- Make a list of what you need to be able to execute your ideas (images, text, other URLs).
- Decide on the "look" you want for this website. What color background? What typefaces? What navigational devices? What will be common on each page? How will you direct the viewer to move about?
- Decide how many images.
- Consider the download time of the images and pages.
- Upload to the server when finished creating.
- Test the site and fix all the offending errors.

CREATIVE EXPRESSION: E-ARTIST BOOK

This book can be a word or picture book or one that combines both. As you would approach an artist book in real-world materials, you will create one in virtual space. This book will have a cover, an index, information about the author/artist, and copyright information, if any. It will have images and words, although it could lean more heavily one way or the other, if that fits most closely into your idea. Most books follow a linear flow mode: in other words, from page 2 to page 3 and so on. You must decide if this book will be linear or nonlinear.

Jeff Gates' In Our Path at http://www.outtacontext.com/iop/index.html.

Nonlinear books will have more than one method of moving from front to back, or page to page. These nonlinear movements will be such things as side trips. The side trips might be in the form of popup extra information from specific pages or it could lead you off into another completely different direction. The side trip might be a secondary story line in a narrative, or it might be a bit of background like an aside, in a conversation. If you have these side trips built in, how will you direct your viewer to the pages missed while on the trip? Sometimes the side trips might lead in a circular fashion. They would take you off into their new place and then lead you back to the beginning. Only you can decide how this will work. This artist book must be more than five pages.

e-Artist books can tell stories, be autobiographical, or be showcases for artists' work. They can be fictional or nonfictional. With the addition of multimedia elements, they can be both time-based and linear. Use of JavaScript or Flash can make this book alive with a variety of animated elements. You will decide which elements will be more special than others and then treat them accordingly. You will give your reader jewels here and there to continue to pique their interest to continue on the journey through your e-Artist book.

Remember that to make your book coherent, there must be some elements that continue throughout the book—perhaps page color, text style, and color or perhaps stylistic illustrations or navigational tools.

You could simulate pages turning in a real-life book or you could have the pages jump from one to the next by means of buttons or arrows that lead the way. Make sure you have looked at other books that you can find on the Web to study the devices that other artists have used to move the visitor through their e-Artist books.

Steven McCarthy makes real hold-in-your-hand books and also interactive books that can be seen on the computer screen or on the Web. The term used for these books is *multiform*, a term coined by former MIT professor Janet Murray. Steven has been working with this notion of artist bookmaking for at least the last five years. The possibilities that surround these multiform books and stories are endless.

If you look at projects like *http://adaweb.walkerart.org/home. shtml*, you will see an interactive project made for the Internet. One could think of this as a book, or one could think of this as an interactive performance. The linkages are very interesting and the project is dynamic with lots of hot spots to take you to a variety of pages, multimedia movies, and JavaScripted elements. You might also look at computer games like the famous Myst, which seems like a mystery in a book that you are trying to solve. Yours won't need to be so complex, and really cannot be, in the time frame of a semester. The variety of

Steven McCarthy's multiform book.

trails one can follow in games like this can show you the complexity that side trips can put into a story line and how one could get lost and never return to the main focus of the project. So, be careful with these asides. Keep them reasonable and comprehensible.

For the first time in the Whitney Biennial's history, an Internet Gallery was included in the exhibition. Usually, the Whitney show is filled with more traditional media like painting, sculpture, and some video. The Intenet gallery showed the work of nine websites created by artists to be seen as artwork of self-expression. While some are collaborations by more than one artist, they are all shown at the Whitney with the same importance as the painting, sculpture, and film work. While at the exhibit, visitors are invited to step in and explore the variety of websites, which were also available through the Internet Art page of the Whitney's own website. These pieces represented artists working all over the United States; some were begun as early as 1995 and others as late as 2000. While they may not all be still up and running, the sites were as follows:

Mark Amerika, Grammatron, 1997—at *http://www.grammatron.com*
Lew Baldwin, Redsmoke, 1995—at *http://www.redsmoke.com*
Ben Benjamin, Superbad, 1995—at *http://www.superbad.com*
Fakeshop, Fakeshop, 1997–99—at *http://www.fakeshop.com*
Ken Goldberg, Ouija 2000, 2000—at *http://ouija.berkeley.edu*
®™ark, ®™ark, 1997—at *http://www.rtmark.com*
John F. Simon, Jr. Every Icon, 1997—at *http://www.numeral.com/ everyicon.html*
Darcey Steinke, Blindspot, 1999—at *http://wwwadaweb.walkerart.org/ project/blindspot*
Annette Weintraub, Sampling Broadway, 1999—at *http://www. turbulence.org/Works/broadway/index.html*

All of this shows that this new medium has infinite possibilities and is being taken seriously by curators of important American museums. Although ephemeral, art created to be viewed over the Internet on one's own computer screen is seen as a viable medium for expression. The commercial value of such art has yet to be tested, but one knows that the making of art is not always for commercial gain. Funding for much of this art came from grants, sponsorship, and self-funding. The future is up to the artists and how they will begin to use this medium for more than self-promotion or research. Like the early days of video, the

possibilities are endless and up to us to discover and promote. With the development moving as fast as it is in this area, the sky seems to be our limit.

Nicci Mechler uses her website for exhibiting her artwork, her games, and her poetry. She approaches all of these forms in a free manner, letting her visitors weave in and out of her ideas. She is a young webmistress, who began writing the script as soon as she became interested in the Web for its rich ideas and ability to allow her and her friends to role play online from home. She is highly inventive and seems to have a never-ending flow of ideas and images into her constantly changing site. It is always a treat to visit and see what is new and what survives her critical eye into the next generation of this work in progress.

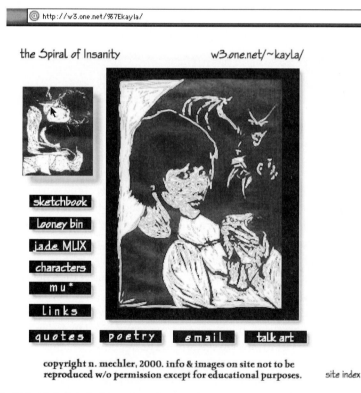

@ http://w3.one.net/%7Ekayla/

the Spiral of Insanity w3.one.net/~kayla/

sketchbook
Looney bin
ja.de. MUX
characters
m u *
Links
quotes poetry email talk art

copyright n. mechler, 2000. info & images on site not to be reproduced w/o permission except for educational purposes. site index

Nicci Mechler's Spiral of Insanity webpage at http://w3.one.net/~kayla/.

12

illumination (chance poem)

the jeweler (a chance sestina)

74

surviving teenagers (or horror movies)

. . . spiral

copyright n. mechler, 2000

. . . site index . . .

Nicci Mechler's poetry page at http://w3.one.net/~kayla/poetry/.

SELF-PROMOTION

Expanded Resume

In this project, you will present yourself to the viewer showing your skills, as well as listing them. You will give examples of the work you talk about in a regular resume and you will show what it is you are capable of doing for a client in a most creative way. Use this project to your advantage by making it elegant, enticing, and reflective of the examples of work you will show. Let your personal style show through. Make the navigational elements clear so that the viewer does not miss what you deem important.

In the example, Steven McCarthy shows by his elegant and clean design what his clients might expect from him if hired to design for them. Steven clearly links to the projects he has done for other clients and talks about his design philosophy along with showing these examples. He also shows some of his interactive bookwork and tells stories. He is giving his visitor a more complete story than any resume could

Steven McCarthy's expanded resume at http://home.earthlink.net/~seminal/.

provide. He is making himself human for his visitor and hopefully engaging that visitor to stay a while. When that visitor is looking to hire a designer, Steven is hoping that the experience of the Web visit will stay in the mind of the visitor and cause him to return.

Jeff Gates also has his expanded resume on his website. He does his in a two-page sequence to further expand the notion that he is a multifaceted guy who does many things. He opens with the *Outtacontext* page that shows a flipping young man in a film or video set of windows and then puts his links at the bottom, which can lead you to a variety of other interesting pages about Jeff and his life. When you roll over the two images of the flipping man, you see that one leads you to the past

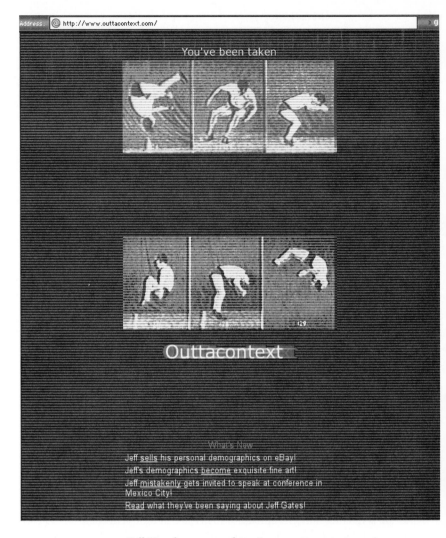

Jeff Gates homepage at http://www.outtacontext.com/.

and the other leads you to the present. On the present page is Jeff's expanded resume; Jeff is a vastly interesting person with many projects and ideas going on simultaneously in his life.

EXHIBITIONS ONLINE

You can create an entirely new exhibition for your site or you can take an existing exhibition and translate it to the Web. In the case of the journey, I made a website for an existing exhibition and translated the

in the early 21st century

During the day,
and sometimes at night
you can
find
Me

working at my first
9 to 5 job

being an artist

teaching
computer graphics

designing web sites

directing ArtFBI

writing

sometimes, reflecting
upon the past

| Working | Being | Teaching | Designing | Directing | Writing | Reflecting |

Jeff Gates' resume/present at http://www.outtacontext.com/present.html. *Clicking on "being an artist" will take you to Jeff's exhibits online.*

sense of the exhibit to the website, filling in with installation shots whenever possible to help the viewer understand my intentions and how the space worked. The website was made to open at the same time as the show. So, much of the work was done before I could go and photograph in the space. I did have the images that would hang on the walls and the objects that would fill the little vignette spaces. I had carefully planned how the exhibit would look, how it would smell, and what the

Steve Davis' Pictures of Failure http://192.211.16.13/curricular/digital_photo/
daviss/MAPLE/MAPLELANE.HTM.

sound would be within the space. All of this information was intended
to be relayed in the website to make it as close to the experience as pos-
sible of being at the show in the real gallery. In the virtual gallery, obvi-
ously, one could not smell the cinnamon that laced the air, but one
could read about it. One could follow the route through the gallery, see-
ing the images in a darkened space like you would in real life.

If you decide to create an entirely new exhibition for the Web, then
consider the following ideas:

- Will you create a false 3D gallery space or will it exist in 2D virtual
 space only? If you are creating a false 3D gallery, you should then
 consider lighting the artwork on the virtual walls. If you are show-
 ing an exhibit that will exist in 2D virtual space only, then how will

you give the viewer the sense of what the exhibit will look like as a whole? Will this 2D start with a page of smaller images and, when clicked upon, open to show the larger version of each work in the exhibit? How will you indicate the relative sizes of the artwork as it would hang in the real world but will only now be seen in your virtual gallery?

- Will you provide an artist's statement that describes the intent of the exhibition and lets the viewer know if the artwork exists in real time and space somewhere?
- Will this be a solo show or a group exhibition?
- Will any of the works shown be from 3D originals such as sculpture, performance, or installation? If so, how will you show that to the viewer? How will the viewer experience the sense of the work when translated into a 2D screen in virtual space?
- Will enlarged images give details not readily seen when looking at only one view of a work of art?
- Will the artist's resume be included in the exhibit?
- Will the works of art be available for sale?
- If you are curating an exhibit of the works of someone else, will you write a curatorial thesis that will be presented with this exhibit?
- Will you give the viewer an explanation of the pieces shown? Will you describe the process used to create the work? Will you give technical instruction as an aside to the exhibit?
- Will you use this as a teaching tool for others less knowledgeable in the arts?
- Will the exhibit have sponsors? If so, how will they be recognized?

RESEARCH AND PRESENTATION: ART HISTORY RESEARCH PROJECT

This project will visually present research already done for a class such as art history. It will include a variety of bibliographical and image sites that are linked by footnotes, images, and/or buttons in the text. All source materials will be noted and new ideas or approaches to the subject matter are encouraged.

In the project example on Giotto, the researchers write the paper, illustrate parts of it, and provide you with many Giotto links on the Web.

In your project, you will have already gotten the relevant feedback from your art history teacher. Incorporate the ideas expressed in the grading of this paper. Then meet with the instructor, if possible, to go over ideas and get some guidance for what you should include in your resources for this project. Sometimes in written papers, photocopies of

The Art of Giotto

For most people Giotto is the first name in European painting since antiquity. That he had breathed fresh life into painting was recognized by his contemporaries, and later by Ghiberti and Vasari. He had "that art which had been buried for centuries by the errors of some who painted more to please the eyes of the ignorant than the intellect of the wise," wrote Boccaccio (some ten years after the artist's death) in a tale of the Decameron, in which he stressed both the physical ugliness and lively wit of "the best painter in the world."

Before Giotto, painting was still considered a craft, a "mechanical" art. Giotto came to occupy a position of great respect in Florence, a city that was one of the most important centres of trade and commerce in Europe. He was representative of that spirit of rationality and efficiency typical of the Florentine mercantile class of the time. Though he was employed by the Bardi and Peruzzi families, owners of the most important European banking houses of the day, he never limited his activity to Florence, and prestigious commissions in other parts of Italy kept him constantly on the move. He worked at the Basilica of San Francesco at Assisi, then one of the most prominent churches in Christendom; for the Pope; for Enrico Scrovegni, the richest and most influential citizen of Padua; for the king of Naples; for Azzone Visconti, the Signore of Milan and he provided the high altarpiece for St. Peter's, Rome. At a

Dr. Emil Kren's Art of Giotto site at http://gallery.euroweb.hu/tours/giotto/index.html.

relevant illustrations are included to reference the work being written about. But in a web-based project, you will be able to show actual examples with ease. Under the fair use for education, you will be able to scan your images from the art history books and include them in your project design. You will be able to make links to them and to other sites that exist on the Web to illuminate the careful research you have done.

Your problem is how you will organize this information to be both visually pleasing to the visitor and also understandable and usable to those readers who will come to your site. If you think of this in terms of a presentation, like one you might do in a class, it will have the form of a slide lecture with relevant illustrations and perhaps some drawn analysis on a layer over the images. You might have some multimedia or animated inclusions in the project to illustrate movement or some point you are making about a certain image or sculpture. You can in-

clude enlarged images from thumbnails embedded in the text. You can include maps, diagrams, and even references to how this work and others appear in museums or galleries. If you have sculpture, you can include digital images of the path you will take when walking around the piece so that the viewer is not stuck with the normal art history face on view of sculpture and really no sense of its form and volume.

Certainly, you have gone to a new museum and looked at a piece of artwork that was familiar to you only from slides or books. When confronted with the original piece in the context of the museum, you might be surprised at its relative size. Remember when viewing images in art history class, all the slides are usually projected at the same size, which is the screen size or the size that is caused by the placement of the projectors in the room. But in real life, in a museum collection, it is amazing to see that some of those Georges Seurat paintings are not enormous, but very small and precious. If you have only seen *Sunday Afternoon on the Island of la Grande Jatte*, you might believe that Seurat only painted extremely large canvases. But if you go to the Courtauld Institute in London, there you will find these tiny wonderful paintings that you have only seen before in slide form or in a book where the size was not noted.

When you work on your website, try to keep in mind that your visitor will probably want some information about size and dates that the artwork was completed. They may also want to know where to go to find the original, or for what purpose a piece was done. Remember to always cite your source for information and use your bibliographical data in the website.

CREATING AN ARTISTS' COMMUNITY: WEBSITE FOR A CLUB OR ARTIST GROUP

This project will create a website for your artist community or club. You will examine how to present the members, the information that needs to be shared, examples of work done by members, and how to allow for contact of the members or officers. Will you have a mailing list for the members? Fine examples of artist communities or artist groups exist on the Web. Research what others have done before jumping into this one. Glean ideas from what you have seen and then decide what will work best for your group.

The site that you will create should have informative text about who your community is and why you exist. If you are a club, give the history and other background on the club. If you are a professional group or society based on your specific art discipline, give the background on that group also. If you have bylaws or a mission statement,

Michael Alstad, Canadian artist, is curator for the site Year Zero One. Michael's own website is at http://www.interlog.com/~alstad *and the website for Year Zero One is at* http://www.year01.com/.

e-mail us at info@theclaystudio.org

139 North Second Street Philadelphia PA 19106 (215) 925-3453 Fax (215) 925-7774

MENU

Exhibition COUPLETS: DUALITY IN CLAY Auction

History * Programs * The Claymobile

Classes * Opportunities for Artists

Current Events * Upcoming Shows * Show Archives * 25th Anniversary

The new Clay Studio's home page can be found at http://www.theclaystudio.org/home.html.

Welcome
Architectural
Design
Furniture
Jewelry
Sculpture
Resources
Site Map
Search Village

Services
Features
Bramble
Project

EXPRESS DIRECTORY LISTING

After visiting one of the sites listed below, if you wish to return here, then close the current window and this directory will automatically appear.

- ◆ **About ArtMetal** - an overview of this site and what it means.

- ◆ **ArtMetal Village** - A descriptive tour of this site.

- ◆ **Welcome Center** - A description of the site, what's new, and a short descriptive guide.

- ◆ **Architectural Center** - Artisan's Showcases, Artisan's Sites and a public forum. Articles and features relating to art and architecture.

- ◆ **Design Center** - Artisan's Showcases, Artisan's Sites and a public forum. Articles and features relating to design work in all forms from interiors to applied arts.

- ◆ **Furniture Center** - Artisan's Showcases, Artisan's Sites and a public forum. Articles and features relating to furniture design and custom work.

- ◆ **Jewelry Center** - Artisan's Showcases, Artisan's Sites and a public forum. Articles and features relating to all phases of jewelry design and fabrication.

- ◆ **Sculpture Center** - Artisan's Showcases, Artisan's Sites and a public forum. Articles and features relating to sculpture.

- ◆ **Resource Center** - Artisan's and Vendor Showcases, Artisan's and Vendor Sites. Resource listings articles and features of interest to the art metalworking community.

- ◆ **ArtMetal Search Engine** - Check this out to find what you may be looking for.

- ◆ **Services** - *Complete information and pricing schedules* for all the services provided by ArtMetal.com including site hosting, mini sites, banner ads and other miscellaneous ways we can help you promote your interests.

- ◆ **Features** - We have a variety of articles and interviews ranging from a showing and review of works to techniques and process not shown elsewhere on the site.

Enrique Vega is the webmaster and founder of the Art Metal Website, which is at http://artmetal.com/.

include that. Among the resources often found on these websites is helpful technical information about processes and techniques used in the discipline. Galleries are often included featuring the work of members of that group. Links may be included to real-world galleries that specialize in work of this discipline. Photographs of members interacting might also be found here. These are often a combination of promotion, self-expression, and instruction.

Your site should have an overall look and feel with some consistency across pages for navigation, jumping off points, and instructive pages. If your club does service projects, then links to those is a good idea. If your group interacts with other groups on a larger arena, then links should be there for the associated groups. Your website should reflect the spirit of the group in its graphics, writing, and layout.

If you do this for your artist community, where will you post it for their use? Does the group presently have a host server or will they be able to use the university server for its host? This should be determined while working on the site, so that it will be useful after it is done and for the future.

URLs Used in This Chapter

- Gabriel Romeu: *http://members.xoom.com/gabrielR/*
- Jeff Gates: *http://www.outtacontext.com/iop/index.html*
- Walker Art Center: *http://adaweb.walkerart.org/home.shtml*
- Whitney Museum of Art: *http://www.whitney.org/exhibition/ 2kb_fs.html*
- Steven McCarthy: *http://home.earthlink.net/~seminal/*
- Nicci Mechler: *http://w3.one.net/~kayla/*
- Steve Davis: *http://192.211.16.13/curricular/digital_photo/ daviss/MAPLE/MAPLELANE.HTM*
- Dr. Emil Kren: *http://gallery.euroweb.hu/tours/giotto/index.html*
- Michael Alstad: *http://www.interlog.com/~alstad* and Year Zero One: *http://www.year01.com/*
- Clay Studio: *http://www.theclaystudio.org/home.html*
- Art Metal: *http://artmetal.com/*

SHORT GLOSSARY
OF
TERMS

Anti-alias: A method used for smoothing the edges of images, text or objects on a computer screen by adding pixels of an intermediate color or tone to visually smooth the edge's appearance.

ASCII: Standard that identifies the letters of the alphabet, numbers and various symbols by code numbers for exchanging data between different computer systems; a computer file that contains text or data consisting of ASCII characters.

Bandwidth: Speed that data is transmitted over the Internet measured in bits per second. Modems may transmit at speeds of 56K bits per second. Cable modems can be at the speed of about 300K bits per second.

Banner: Commercial ads that usually appear at the top of the webpage.

Bitmap: Pixel-based images, most often photographic images with continuous tones.

Bookmark or Favorite: Found on your browser, this feature lets you save a link so that you might be able to go there quickly later.

Browser: Software used to communicate with web servers and serve as the platform upon which you use the World Wide Web or Internet. The most common browsers used are Netscape Navigator or Communicator or Microsoft Internet Explorer.

CGI: Common Gateway Interface. A language or set of rules that lets browsers and servers exchange information based on requests sent by the browser. The requests might be a query to a database by a web page or it may request that information on a page is mailed to a specified email address.

CGI Script: A short program usually residing on the web server that allows access to a program that then performs a requested task or action. Processing forms on web pages might be one of these actions.

Client: The computer that you use that requests service, such as an Internet hookup, from another computer known as the server.

Color Depth: The number of colors shown on your monitor. Described also in bits: A 1-bit image has only black and white, an 8-bit image has up to 256 colors, and a 24-bit image has up to 16.7 million colors.

Color Mode or Model: Method that describes or defines colors. RGB is Red, Green, Blue and used for additive color of light. Printed color or reflective color is describe in CMYK for Cyan, Magenta, Yellow, and Black. These are subtractive colors. Indexed Color is built on a system of no more than 256 colors. Greyscale can have as many as 256 shades of grey.

Compression: Reduction in the file's storage size in order to speed up the transmission of the file, reduce its storage size, or speed up the download. Compression does not change the physical size or dimensions of the image only the storage size. Using compression such as a JPEG can alter the way the image displays because it can substitute close colors or tones.

CSS: Cascading Style Sheets. Sets of rules in HTML to control how pages are displayed on a browser. In these you can set the font, point size, colors, and locations plus other attributes of the page so that the visitor sees the page in its best light. Not all programs that let you create web pages use this convention.

Dynamic pages: Pages with animation, actions, layers of JavaScript that use DHTML (Dynamic Hypertext Markup Language).

Dithering: Visual blending of colors to appear to simulate colors that are not present. Dithering will soften the edges of an image and appear to blend. Jagged edges are dithered to appear smooth in print or on screen.

Downloading: Receiving *from* the server to your computer hard drive or disk.

DPI: Dots Per Inch. Resolution of images is given in dpi. 72 dpi is a usual resolution for web images. The lower the number, the less the resolution. Images with higher resolution will output to printers or imagesetters better, but for use on the Web are unnecessary or unwanted because of the length of time it will take to download or appear on the screen.

EPS: Encapsulated PostScript. A format not used in web development.

Font: Typeface sets of upper and lower case characters, numbers, punctuation marks. Some typefaces are specifically optimized for the Web.

SHORT GLOSSARY OF TERMS

Frames: A feature of HTML that allows you to divide the screen up to allow multiple documents or pages to appear at once in a browser window. Usually this is accomplished by the use of scrollbars on the various windows or cells of the frames "page".

Frame rate: Rate at which animations will play in frames per second. The higher the frame rate, the smoother the animation looks when played and also the larger the file size. This will be used in LiveMotion and in Flash animations.

FTP: File Transfer Protocol. For the Macintosh, Fetch is a popular FTP program. FTP allows computers to transfer files to Internet servers or between computers. This is what you use to upload your completed web pages to the host server that will hold your website. This is also what you use to download files from web servers. Used in ftp addresses as in ftp: ftp.nku.edu.

GIF: Graphic Interface Format. A cross-platform bitmap file format that has as many as 256 colors. There is a GIFa format that supports transparency in an image, interlacing (allowing every other line to load) and animation, and is one of the most common file formats for graphics on the Web. The other most common format is JPEG.

Host: Hosts are Internet providers. It is your server; it is also called your ISP (Internet Service Provider). It is a powerful computer with permanent access to the Internet, allowing you to store your web pages or email upon it.

HTML: Hypertext Markup Language. Uses tags to define structural elements of documents published on the Web, including links to other documents, and to style. HTML documents are platform independent meaning that an HTML document created on a Mac will be able to be viewed on a PC with no need for translation. Browsers read the HTML and translate the commands embedded in it to create the graphical page you see on your browser.

http: Hypertext Transfer Protocol. Used in URL addresses to tell the server how to send the information as in: *http://www.nku.edu.*

Image Map: An image used for navigation on the Web. Specific areas of the image will link to other pages out on the Web. These spots or areas are called hot spots. Clicking on these hot spots will take you to the other pages.

Indexed Color: An image mode that contains up to 256 colors based on a specific palette. GIF images are done in indexed color.

Interlacing: Capability of a GIF image to appear gradually in the browser so that the image is watched gradually moving to a higher resolution as it is downloading. This gives the visitor to the page something to watch while waiting. An interlaced image may appear

blurry when beginning to load onto the web page and gradually seems to come into focus as the rest of the image loads.

Internet: Interconnection between a global network of computers that is decentralized. It was originally financed by the government of the U.S. to facilitate communication between the government, the scientific community, and the academic world.

ISP: Internet Service Provider. Like Earthlink or your host.

JavaScript: A scripting language developed to allow HTML to have interactivity and dynamic content such as animations, sound, and rollover effects on web pages.

JPEG: A compressed bitmap file format designed for photographic images or images with many subtle color transitions. Named for Joint Photographic Experts Group, which developed it. The other most common format is GIF. Sometimes the .jpeg or .jpg suffixes are interchanged although they refer to the same kind of image file. Make sure you correctly record them in your link addresses.

Keyframe: In animations, these frames are the ones that begin the element showing up or going away. Usually marked by tween frames in between where actions or other attributes of the element may change. See LiveMotion discussions.

Keyword: Words used to describe the content of a web or HTML page that is used by search engines to locate relevant pages. Keywords are reflective of the intention of the pages on a website or the content within the specific page. There are conventions for using keywords that make them more effective.

LAN: Local Area Network. This will be a network that is restricted to a specific local area, such as all the computers at your location that are connected to a central printer, for example. It might be a group of computers that are linked together to share resources like a small server or sharing files.

Link: Another term for Hyperlink, which is an element on a web page that when clicked with the mouse takes you to another page on the Web or a part of the document you are viewing.

Listserv: Email that is transmitted only to subscribers.

Loop: Continuous repetition of an animation for specified time or forever in playback.

Low-Source Image: A low resolution bit map image that appears in your browser window before the higher resolution full color image is loaded giving the viewer something to look at while the larger image is loading.

Metatag: A part of the HTML code that gives information about the web page such as keywords, or comments that are used by search engines.

Moiré: Pattern caused by scanning a halftone image when the screens conflict. If you encounter this when scanning images for your web pages, change the resolution at which you are scanning.

Navigational system: A graphical system used to let visitors find their way through your website. These are often buttons or systems of buttons.

Net: Abbreviation for the Internet.

Opacity: Degree of transparency in an image, text, or object.

Optimize: Saving graphic files for use on the Web in the most appropriate file format and size. Smaller file size, with better clarity of the image, is what you are trying to achieve.

Page: An HTML document containing images, text, links and other elements. While not a physical thing like a book page, it acts as though it were—an electronic "page".

Palette: A set of colors that can be applied to an image. Indexed color palettes consist of 256 colors and JPEG images have palettes that have more colors.

PDF: Portable Document Format. A format developed by Adobe for electronic files used for a variety of purposes including the publishing of postscript files to the Web and display of documents with original format and typefaces intact.

Pixel: Abbreviation for "Picture Element". The smallest element of measure on a scanner or monitor.

PNG: Portable Network Graphics. A graphics format.

PPI: Pixels Per Inch. A measurement of resolution of on-screen images. *See* DPI.

QuickTime: A video format developed by Apple Computer to show movies on a computer and on the Web.

Resolution: Degree of detail contained in an digital image, determined by the number of pixels or dots per inch (ppi or dpi). Web images are generally 72 pixels per inch.

RGB: Red, Green, Blue. Additive light color system used for display of images on computer monitors to create full spectrum of color. CMYK is the system used for reflective color used in printing: Cyan, Magenta, Yellow, and Black.

Rollover: An effect triggered when a mouse cursor moves over the activated part of a web page on a computer screen. JavaScript is used to create these effects. When triggered, the rollover may change appearance, activate an animation or sound, or send another image to be visible on the screen.

Search Engine: Software program that lets the viewer search for content across the Web or on a specific site.

Server: Your host computer; your ISP. A powerful computer with a permanent connection to the Internet or one that stores programs or files.

Site: Website. A collection or group of pages linked together with a set of navigational devices such as buttons that reside together on one or more servers.

Shockwave: Macromedia's software that compresses, exports and streams Director movies for the Web. Component plug-ins for Shockwave are used in your browser to replay these movies.

Slice: A part of an image that makes up a whole image that appears on or as a web page. Usually these slices are optimized individually or are a part of an ImageStyler page. Sliced images will load faster because the whole loads in parts and is assembled on screen.

Source Image: A graphic file that is part of a web or HTML page.

Streaming: Transferring text, sound, graphics, animations and Quick-Time video over the Web in a continuous stream that displays as it downloads rather than when it is finished.

SVG: Scalable Vector Graphics. A new standard for the Web, describing shapes and paths rather than pixels that make up a shape. SVG is a more efficient language and therefore quicker, with more compact files.

SWF: Flash based animations that are generated by LiveMotion and Macromedia's Flash. Flash plug-ins are necessary for replaying files saved as .swf on the Web.

Tables: A set of tags and attributes that allow HTML content to be displayed in cells with rows and columns giving the web page developer more control over where elements appear on a web page. Without the use of tables you cannot really control where things will be displayed on your page when writing your own HTML code. With the use of newer web development programs this capability is built in and the use of tables is not necessary for most designs.

Tags: Codes used for defining content on a HTML or web page. The structure, reference and style are defined in these tags. Remember when you looked at the source for a page that was <p> for the beginning of the paragraph and was </p> for the end?

Transparency: Pixels with no color value that allow the background color, image, or pattern to show through. *See* opacity.

URL: Universal Resource Locator. The web address of documents or sites.

Vector: Method of describing or storing objects using mathematical coordinates. Vector programs commonly used are Illustrator and Freehand.

Web-safe Palette: A set of 216 colors common to both the PC and Mac operating systems that will display the same when seen in a browser using 8-bit color. 8-bit color is a color palette of 256 colors or less.

World Wide Web: The computers on the Internet that serve linked, formatted HTML documents all over the world. *There is no there, there.* Because servers are added everyday, the Web is constantly growing and changing. Not all Internet servers are a part of the World Wide Web, but all World Wide Web servers are a part of the Internet.

W3C: World Wide Web Consortium, made up of a network of programmers at a variety of companies and organizations that work together to establish standards for the Web and web languages. Together they are developing the new standards for SVG.

XML: Extensible Markup Language. A dynamic system for defining other languages used on the Web. It separates the structure and content from the presentation. Its strength is that it interacts with the objects on the screen and defines the structure of the document so that it can be viewed or used in exchanging information. It is used in HTML documents and is very new and still being developed.

INDEX